# BREWING IN LONDON

JOHNNY HOMER

AMBERLEY

*This book is dedicated to London's brewers past and present. It truly is a city of beer.*

*Back cover*: Image courtesy of London Metropolitan Archives, City of London.

First published 2018

Amberley Publishing
The Hill, Stroud
Gloucestershire, GL5 4EP

www.amberley-books.com

Copyright © Johnny Homer, 2018
Crown Copyright and database right, 2018

The right of Johnny Homer to be identified as the Author of this work has been asserted in accordance with the Copyright, Designs and Patents Act 1988.

ISBN 978 1 4456 7025 6 (print)
ISBN 978 1 4456 7026 3 (ebook)

All rights reserved. No part of this book may be reprinted or reproduced or utilised in any form or by any electronic, mechanical or other means, now known or hereafter invented, including photocopying and recording, or in any information storage or retrieval system, without the permission in writing from the Publishers.

British Library Cataloguing in Publication Data.
A catalogue record for this book is available from the British Library.

Typesetting by Amberley Publishing.
Printed in the UK.

# Contents

|   | Introduction | 4 |
|---|---|---|
| 1 | Hops, Beer and the Birth of an Industry | 8 |
| 2 | South of the Thames – Thrales, Barclay Perkins and the Rise of Courage | 16 |
| 3 | East End Brewers – A River of Beer | 30 |
| 4 | They Also Brewed – Watney, Whitbread, Fullers, Meux and Young's | 46 |
| 5 | The Death and Rebirth of Brewing in London | 68 |
|   | Acknowledgements | 94 |
|   | Bibliography | 95 |

# Introduction

One of the smells of my childhood was the smell of brewing. Until the age of twelve, I lived in the St Luke's area of London, a working-class quarter of the capital located next to the super rich Square Mile of the City of London itself. This was the mid-1970s, a period when London still had a substantial brewing industry, albeit one that had been in steady decline for many years. As I hope to show in this book, things would get much worse before they got better.

The Whitbread Brewery, Chiswell Street.

Central to life in St Luke's was Whitecross Street, a bustling 'Cockney' London street market the likes of which are sadly these days few and far between. Whitecross Street ran south from Old Street to Chiswell Street, where the old London Borough of Finsbury and the City met. It was in Chiswell Street where the mighty Whitbread Brewery stood, the source of those memorable childhood aromas.

Whitbread had been brewing here since 1750 and represented a major industrial operation in the heart of the mighty metropolis. They were not alone in their malty endeavours.

A short stroll east would bring the intrepid perambulator to Truman's sprawling Black Eagle Brewery, while further east one would find the Albion Brewery in Whitechapel Road and Charrington's Anchor Brewery in Mile End.

To the west, in Chiswick, was Fuller's, while at the huge Park Royal Brewery, North Acton, millions of kegs of Guinness were produced each year. Across the Thames could be found Courage's Anchor Brewhouse, while Wandsworth was home to Young's. There were others too.

## Rise and Fall

The historian and writer Martyn Cornell has chronicled the disappearance of London's brewing industry over the years. He suggests that there were more than 160 in 1850 and as many as ninety in 1904. There were still sixty-five the year before the First World War, forty-two in 1923 and twenty-five in 1952. In 1976, reckons Cornell, there were just nine.

But from the depressing landscape of the late 1970s, London – the city which many years previously had given the world such seminal beer styles as porter, IPA and Imperial Stout – has been transformed once more into a world mecca of brewing. In the

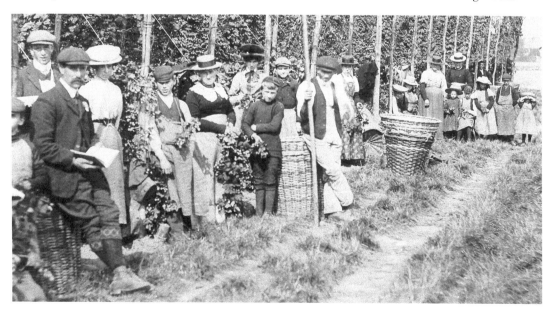

Cockney hop pickers in kent, around 1900.

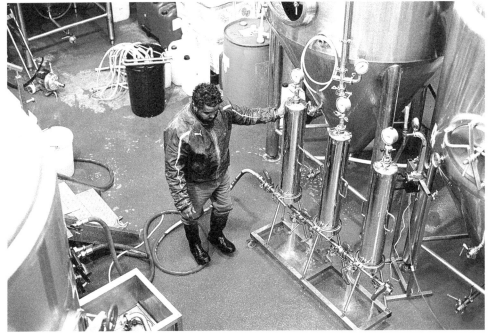

*Left and below*: Scenes from the Portobello, one of London's many new breweries.

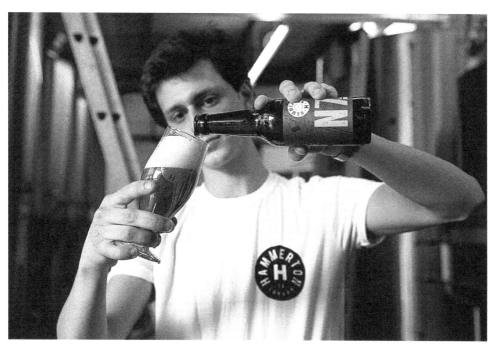

After a gap of more than sixty years, the Hammerton name has returned to London's brewing scene.

past decade or so the micro and craft brewing phenomenon has taken the country by storm, and London is at the heart of that revolution. At the time of writing in early 2018, there were more than 100 brewers in the capital, ranging from cutting-edge producers of craft beer through to cask brewers with a contemporary edge. It's also good to see some famous old London brewing names return, namely Hammerton and Truman's, in North and East London respectively.

And let's not forget Fuller's, who while the rest of the capital's major brewers either closed or deserted London, continued to brew great beer from their historic headquarters on the banks of the rolling Thames.

A book of this size can't possibly hope to cover the entire story of brewing in London, past and present, nor does it attempt to. There have been hundreds, quite possibly thousands, of active brewers throughout the capital's long history and here I have concentrated, for the most part, on the major players.

The aim, then, is to give an overview of the capital's brewing history and I hope the book will inspire you to dig deeper (please see bibliography for suggested sources) and, perhaps most important of all, to drink London beer with a newfound appreciation of its rich heritage and exciting future. I'll see you at the bar. Mine's a pint of porter.

# I

# Hops, Beer and the Birth of an Industry

'Hops and turkeys, carp and beer,
Came into England all in one year.'
Old English rhyme

There are several versions of the above rhyme, and they all emphasise the impact that the arrival of the hop had on English life and English brewing. Indeed, a strong case can be made for the claim that without hops, the brewing industry in London, and indeed the brewing industry across the British Isles, would have developed very differently.

The introduction of the hop transformed London's brewing industry.

Before the arrival of the hop – and therefore before the arrival of beer – there was ale, the drink of old England and hence the drink of London. Ale was the drink of Chaucer's pilgrims and also audiences at Shakespeare's Globe. Ale, of varying quality and strength, was the drink of rich and poor, of young and old, of men and women, and children too. In an age when there was no guarantee that the water you consumed was safe, ale offered hydration and nutrition with added peace of mind. It was essential to life in medieval England.

Brewed from malted barley, water and yeast, ale stood distinct from beer, the Continental drink brewed with the addition of hops. Ale was often flavoured with a 'gruit' of assorted herbs, sometimes spices. The brewing of ale was mostly undertaken by women and mostly carried out on a domestic scale, although many innkeepers would also have brewed on their premises. Alewives, as these woman were sometimes known, brewed ale for the home, selling on any excess locally.

In the bigger towns and cities, however, large-scale brewing did take place, and here a nascent industry was already established. This was especially the case in London, due to its size, population and demographic complexity. The population of the capital around 1200 has been estimated at between 80,000 and 100,000. By 1550, it had risen to around 120,000. London was then, as now, a very thirsty place.

## St Paul's Cathedral

One of the many benefits that hops brought to the brewing table was that in addition to imparting bitterness, flavour and aroma, they also helped to stabilise and extend the life of beer. Ale, without the preservative properties of the hop, had a limited life, and this in turn prevented large-scale commercial production.

There were exceptions, however. Some of the largest brewers in medieval England were religious institutions, and this was the case in the capital, where records show that in 1286 alone almost 68,000 gallons of ale was produced at St Paul's Cathedral, mostly for internal consumption. Brewing would have taken place every three to four days to maintain a constant supply of fresh ale, although very little of this ale was sold commercially – just 37 gallons in 1286, according to records.

It has been estimated that in 1420 there were around 290 brewers of ale in London, and from the thirteenth century onwards the industry was heavily regulated and taxed. As a result, and in an attempt to stand up for themselves, London's brewers united. In 1342, in the City of London, the Mystery of Free Brewers was established, while the Worshipful Company of Brewers, one of the City's oldest livery companies, is recorded as early as 1292 and was granted a royal charter by Henry VI in 1437.

## Hopped Beer

These trade organisations, influential and powerful, did not initially welcome the arrival of the hop. It was even branded a 'pernicious weed' by some, although its use was never banned. Some Londoners had already developed a taste for hopped beer as early as the second half of the fourteenth century. As Ian S. Hornsey details in *A History of Beer and Brewing*, in August 1372 Henry Vandale bought four barrels of 'beere' from a merchant based in the Pool of London. This 'beere' was almost certainly imported.

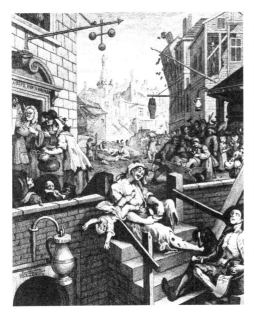 

Hogarth's *Gin Lane* and *Beer Street*, both 1751, reinforced the view that beer was good and gin was bad.

By the early fifteenth century, hopped beer was widely available in London – given the capital's cosmopolitan population, this is not surprising – and it is likely that much of it was brewed in London, although the hops would have been imported and the brewers were probably Dutch, Flemish or German. This hopped beer was brewed outside the heavily regulated City, most likely in Southwark across the Thames, and was thus free of interference from the powerful trade guilds. Certainly in 1425 these guilds, representing London's ale brewers, were complaining to anyone who would listen of these 'alien' brewers of hopped beer.

It is widely acknowledged that the first cultivation of hops in England was in Kent during the early fourteenth century. A date of 1520 is often given. However, Margaret Lawrence, in her book *The Encircling Hop*, suggests hops were being grown on a small scale by Flemish immigrants near Cranbrook, Kent, as early as the 1330s.

Whenever and wherever the first English hops were grown, they would change both the business of brewing and the style of beer consumed in England.

## Hour Glass Brewery

One of the first of the great London breweries was the Hour Glass Brewery in Thames Street, later Upper Thames Street, in the heart of the City of London. The brewery backed onto the Thames and occupied a site immediately to the east of today's Cannon Street station. An image from the *Brewers' Journal* of November 1883 shows the two standing side by side.

Records show that brewing had taken place here since 1431, with John Reynolds at the helm. The Reynolds family ran the brewery, with a variety of partners coming

and going, for several generations – including its destruction in the Great Fire of 1666 – until around 1730, when it passed into the ownership of the Calvert family.

The Calverts would become one of the great dynasties of London brewing, although today they (rather unfairly) rarely get mentioned in the same breath as the likes of Courage, Thrale, Truman or Whitbread. The family's involvement in brewing started around 1657 when Thomas Calvert married Anne Ambrose, whose father, William, was a co-owner of the Peacock Brewery in Whitecross Street, St Luke's. The Peacock brewhouse had been established around 1550 by John Pullen.

Calvert spent just over a decade at the Peacock before his death, aged just forty-six, in 1668. His younger brother, Peter, had followed him into the company, however, and it seems that the Calvert name was already well established in London brewing circles.

For a period in the eighteenth and early nineteenth centuries, brothers John and William Calvert found themselves at the helm of, respectively, the Peacock and the Hour Glass – two of London's most productive breweries. Both had seen their market share diminish steadily for many years, and in 1810 they merged, with the brewing operation being transferred to Upper Thames Street.

From 1823 the business traded as Felix Calvert & Co., but in 1860, after severe financial difficulties in 1859, became the City of London Brewery and, in 1891, the New City of London Brewery, although the 'new' prefix was dropped in 1895.

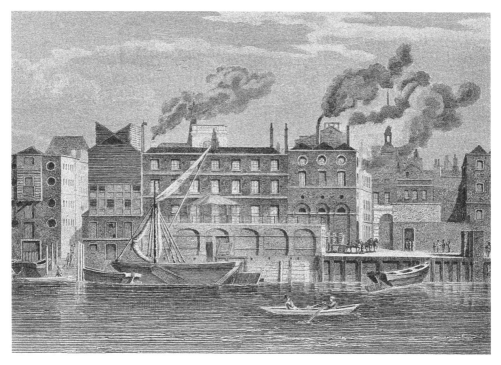

The Hour Glass Brewery is a hive of activity, c. 1821. (London Metropolitan Archives, City of London)

City of London Brewery label, complete with hourglass trademark.

Although their market share continued to fall in real terms, they were now brewing more beer than ever and were trading successfully enough in 1883 to finance the rebuilding of the brewery to a grand design, courtesy of the prolific Leeds-based brewery architects Scamell & Collyer.

In 1919 they acquired a stake in Croydon's Nalder & Collyers brewery, and their 170-strong pub estate, and bought Stansfield & Co. of the Swan Brewery, Fulham. Two years later production was moved from the Hour Glass to Fulham, but as the decade unfolded the flow of once-celebrated City of London Brewery beer slowed to a trickle, until it stopped completely around 1928.

Most of the City of London Brewery's pub estate was sold to Hoare & Co. and the Swan was adapted to produce bottled mineral water rather than beer. The Hour Glass brewery itself was used as a warehouse until it was destroyed by German bombing in 1940. It was demolished in 1942.

The City of London Brewery Company became the City of London Brewery Investment Trust in 1931 and continue to trade today as the City of London Investment Trust.

## Red Lion Brewery

Another of London's early major breweries – declared 'London's oldest brewery' by one twentieth-century commentator – could be found a mile or so to the east of the Hour Glass in the form of the Red Lion Brewery, Lower East Smithfield, in the old parish of St Katherine's. There is a record of brewing here from 1511, when a

John Pytman acquired a lease, although a date as early as 1492 is suggested by the Brewery History Society. The Red Lion was located on or near the site of the old brewhouse that provided ale to the hospital of St Katherine. This was an early centre of brewing in London, and here stood a public brewhouse where Londoners could pay to bring their own ingredients and brew their own ale.

The Red Lion changed hands a number of times over the years, notably enjoying a long period under the control of the well-connected Parsons family. Sir John Parsons, Master of the Brewers' Company, was Lord Mayor of London in 1703. On his death in 1717, the business passed to his son Humphrey, who would be lord mayor twice himself, in 1730 and again in 1740, when he died in office.

It was during his first term as lord mayor that Parsons was invited to join a royal hunting party that included Louis XV of France. The French king was so impressed with Parsons's horsemanship, and also with his steed, that the mayor gifted him the horse. By way of thanks the king awarded the Red Lion the 'exclusive honour' of providing the French court with porter, without the burden of import taxes.

A new brewhouse was constructed in 1792, and at one point the brewery site covered some 3 acres, drawing its water from a well 300 feet deep and having its own Thameside wharf. They were also the first brewery anywhere in the world to incorporate steam power into the brewing process, installing an engine by Boulton & Watt during the summer of 1784. Or were they? Hornsey, quoting a 1930 history of Boulton & Watt, suggests that the Stratford brewers Cook & Co. were using a steam engine as early as 1777. Whatever the truth, where the Red Lion went, their rivals followed, and engines were soon installed at, among others, Calvert's and Whitbread.

## Hoare & Co.

In 1802 George Matthew Hoare, of the renowned London bankers C. Hoare & Co., acquired a substantial share in the Red Lion, which promptly began trading as Hoare & Co. The company, by and large, seems to have remained financially healthy in a very competitive market, although in 1826 Hoare had to seek help from his father, Henry, to avoid bankruptcy.

The following year much of the area surrounding the brewery was redeveloped to build St Katherine's Dock, but the Red Lion survived, although only by a matter of yards.

Hoare & Co., despite being one of the earliest and pioneering mass brewers of porter, were later overtaken by the likes of Barclay Perkins, Truman's and Whitbread when it came to both output and profit. A proposed merger with the City of London Brewery in 1911 made some business sense (they were similar in size and standing, after all), but never happened. Instead, Hoare's acquired a controlling share in the Mitcham & Cheam Brewery, adopting that brewery's Toby Jug trademark.

In 1933, after many years of financial struggle, Hoare & Co. were bought by Charrington, who somewhat ironically are the company we now most strongly associate with the famous Toby Jug image. Brewing stopped at the Red Lion Brewery

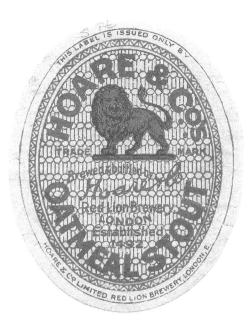

*Above left and right*: Labels for Hoare & Co.'s Burton Ale and Oatmeal Stout.

*Left*: Rare surviving Hoare's pub livery at the George IV, Portugal Street.

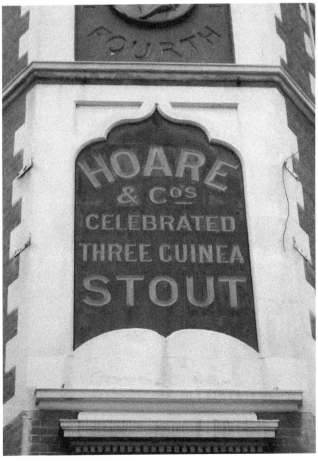

in 1934 – at the time they were still brewing milds, an IPA and a brown ale alongside Hoare & Co.'s hallmark dark beers, namely a porter, a stout and their fabled Imperial Ale – although the Hoare name lived on as a brand briefly. The Red Lion Brewery was demolished in 1935.

## Growing Industry

While the likes of the Hour Glass and the Red Lion continued to grow, many smaller companies also continued to trade, if not perhaps thrive, and at the end of the seventeenth century there were almost 200 commercial brewers in London. In time many of these smaller operators would fall by the wayside, and the overall number of brewers fell steadily, although ironically as this happened the amount of beer being brewed increased.

The Red Lion and the Hour Glass were among the first in the capital to embrace the idea, and the reality, of brewing on a truly industrial scale. But as London's population grew, a number of other major players emerged.

Throughout the eighteenth and nineteenth centuries, vast fortunes would be made, and occasionally lost. Once humble brewers would become rich beyond their wildest dreams, some would even win election to Parliament and be elevated to the peerage, or 'beerage' as this rise through the social ranks was known.

What was becoming clear, as the eighteenth century unfolded, was that London was about to become the brewing capital of the world.

# 2

# South of the Thames – Thrales, Barclay Perkins and the Rise of Courage

> "The sight of a great London brewhouse exhibits a magnificence unspeakable.'
>
> Thomas Pennant

At the beginning of the eighteenth century, London's population had grown to an estimated 600,000. It would pass the 1 million mark in the early nineteenth century and continue to grow, reaching 2.6 million by the time of the Great Exhibition in 1851 and 3.1 million a decade later. For much of the eighteenth and nineteenth century London was the largest city on the planet, a mighty metropolis of commerce and trade. To cater for this mass of humanity, a torrent of beer flowed from hundreds of different breweries.

While old style English ale still had its provincial strongholds, by the start of the eighteenth century hopped beer had become increasingly popular with London drinkers. As the century progressed, the hopped drink became the dominant style, and in time the terms 'beer' and 'ale' would become synonymous with each other.

Among the most commonly consumed styles in London were a lightly hopped ale, thus quite sweet, and a more heavily hopped, bitterer beer. It was not uncommon for drinkers to combine the two. Pale ales were also coming into fashion, but these were more expensive to produce, and hence to drink.

Not everyone was fond of hopped beer. In 1763 Casanova arrived in London and, although he found English women to his liking, was not impressed with the beer, commenting that it was 'so bitter that [he] could not drink it'.

Perhaps inevitably some smaller brewers went under, unable or unwilling to adapt to the changing London market, but there were still around 150 as the nineteenth century approached. The bigger concerns established in the seventeenth century (mostly) continued to thrive and grow – namely, the Anchor Brewery in Southwark, the Hour Glass in the City, the Red Lion and Truman to the east and the Stag in Westminster – but a number of new companies were also emerging.

# South of the Thames – Thrales, Barclay Perkins and the Rise of Courage

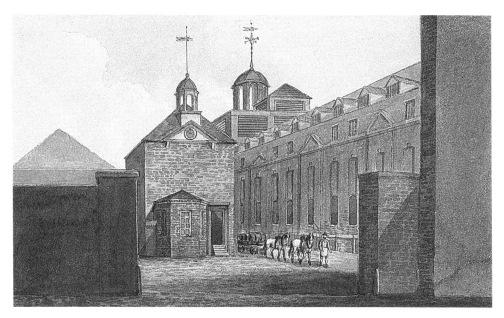

The Anchor Brewery, from a watercolour c. 1826. (London Metropolitan Archives, City of London)

As big as some of these companies had become, a style of beer would emerge in the early part of the eighteenth century that would help transform a few of them into brewing giants the likes of which had never been seen before. The beer in question would become known globally as porter, the first of several very distinct styles that London would give to the world.

## Porter

The history of porter is far from clear, which given the dark colour of the beer itself seems somehow apt.

A popular and much repeated version of its creation mentions a brewer called Ralph Harwood, of the Bell Brewery in Shoreditch, East London. London drinkers, so the story went, were fond of something called three-threads, which consisted of a third of ale, a third of beer and a third of 'twopenny' all served in the same tankard. This required three visits to three separate casks by the server. Harwood, the legend goes, was the first brewer to perfect a beer that combined the qualities of all three styles in one. The year 1722 is often given for this momentous event.

Although Harwood was indeed a London brewer – and a fairly minor one in the grand scheme of things – there is absolutely no proof that he was the brains behind the beer, although the Bell was certainly producing porter. A pub originally called the Last – since the 1870s, the Old Blue Last – just yards from where the Bell brewhouse once stood has long claimed to be the first place where porter was sold.

The more likely story is that porter was developed as a reaction by London brewers to the growing popularity of pale beers, in particular pale ales. Porter was notable for its generous use of hops, dark malts and also for being given a lengthy

period of maturation. Although it is mentioned by name as early as the 1720s, it would be several years before it was perfected as the beer that would become globally popular.

Porter acquired its name because of its popularity with the thousands of porters who lived and worked in the capital. These men were responsible for keeping London's commerce moving, transporting and unloading goods all across the capital. It was physically demanding work, and the calorific and nutritional value of porter probably also helped endear it to these men. It tasted good too, of course.

## Vats

Central to giving porter its unique character was a lengthy period of storage after fermentation, sometimes for a whole year. Initially, porter was stored in individual butts (a butt held 108 imperial gallons), but as demand grew so too did production, and this meant storing beer on a huge scale. This, in turn, involved substantial investment, and those breweries that were able to provide that investment were the ones that flourished.

In 1736 the Red Lion Brewery had a number of huge porter vats installed that were each capable of holding 54,000 gallons – a formidable 432,000 pints. The quality of the Red Lion's porter was, according to contemporary accounts, exceptional. The poet and playwright Oliver Goldsmith called it 'Black Champagne'. Ken Smith, in his book *Brewing in Britain*, reckons that the Red Lion could 'probably' be 'referred to as the place where porter began'. A claim to fame indeed.

Fifty years later, in 1786, the noted antiquarian Thomas Pennant wrote in something close to wonderment of the Griffin Brewery in Clerkenwell. Pennant detailed one vessel '60 feet in diameter, 176 feet in circumference, and 23 feet high'. This fantastic beast apparently cost £5,000 to construct and could hold as much as '12,000 barrels of beer, valued at about £20,000'. That's close to 3.5 million pints of porter. When the vat was completed, 200 people gathered inside to celebrate with a slap-up dinner, washed down, one assumes, with lashings of beer.

In 1790 Pennant wrote that, 'The sight of a great London brewhouse exhibits a magnificence unspeakable.' He was spot on, not least because many of these new breweries were constructed on a grand industrial scale never seen before. By 1786 the capital's brewers were producing around 5 million barrels of beer a year. London truly was the brewing capital of the world, and some of the companies involved were set to become household names.

## The Anchor Brewery

As early as 1330 Southwark had been noted as one of London's centres of brewing, known for its large number of so-called 'foreign brewers', predominantly Flemish, from Europe. They flourished here outside the jurisdiction of the powerful brewing guilds that operated on the opposite 'City' side of the Thames, and their use of hops also distanced them from the native ale brewers. John Stow, in 1598, counted twenty-six brewers concentrated in a small area along the Thames in both Southwark and near the Tower of London.

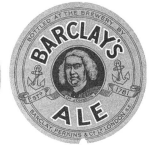

**BARCLAY'S RUSSIAN IMPERIAL STOUT**

THIS STOUT WAS BREWED IN 1935 THE YEAR IN WHICH THE SILVER JUBILEE OF HIS LATE MAJESTY KING GEORGE V. WAS CELEBRATED

**JUBILEE BOTTLING**

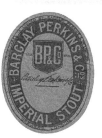

A selection of Barclay Perkins labels. Dr Johnson features prominently.

Southwark was also the home of numerous brothels, bear-baiting pits and several theatres, notably Shakespeare's Globe, and it is against this rich historical backdrop that, around 1616, James Monger, 'Citizen and Clothwroker of London', established what would become the Anchor Brewery. It originally stood in Dead Man's Place, adjacent to the Globe itself. The theatre had burned down in 1613, during a performance of *Henry VIII*, but was swiftly rebuilt, surviving until 1644. In later years the Anchor would occupy the land upon which the Globe had once stood.

The brewery stayed in the ownership of the Monger family until 1670, when it was acquired by James Child, sometimes knows as Josiah Child. The Child family had strong links with the Navy, having become rich, according to John Pudney's *A Draught of Contentment*, from providing 'masts, yards and bowsprits as well as stores and beer' to the senior service. This would explain the adoption of the Anchor Brewery name.

Around this time a young man from St Albans called Edmund Halsey enters the story. Within two years of joining the Anchor as 'Broomstick Clerk', he had, by 1693, become a partner, marrying Anne, Child's daughter, along the way. Halsey seems to have been a man of many talents, for he both managed the business and was also one of the senior brewers.

The company was profitable at this stage, but even greater success was to come. When Child died, leaving the business to his widow, Halsey bought it from her in

instalments. In the subsequent years he became a wealthy man, dabbled in politics – not without controversy – and acquired substantial tracts of land outside London.

Without a son to follow him into the business, Halsey employed a young nephew from Hertfordshire by the name of Ralph Thrale. The young Thrale was, as Halsey had been before him, a natural when it came to the machinations – both practical and financial – of the brewing business. But when Halsey died in 1729, Thrale was not mentioned in the subsequent will. Pudney suggests that Thrale had rather put his mentor's nose out of joint many years previously by marrying a young lady who Halsey had in his sights as a prospective bride of his own.

This did not deter the ambitious Thrale. After much legal wrangling he set about purchasing the business in instalments (again mirroring Halsey), paying the not insubstantial sum of £30,000 over an eleven-year period. This was good business, as the brewery thrived and Thrale became rich and influential. He also became Member of Parliament for Southwark, yet again mirroring Halsey.

## Dr Johnson

However, it was after his death in 1758, when the brewery passed to his son, Henry, that the company really came to prominence. In 1953 the economic historian Peter Mathias wrote an 'account of the growth and development' of the Anchor Brewery, and it is through this research that we have such in-depth information about the output of the Anchor, and some of their competitors.

In 1758, the year Thrale Senior died, the Anchor produced 32,622 barrels, lagging far behind rival London brewers such as Truman (55,506) and Whitbread (64,588). Output rose under Henry's leadership, slowly at first, until by 1777 they were giving the opposition a real run for their money, producing 85,287 barrels per annum against Whitbread's 110,440 and Truman's 80,936.

Henry Thrale was at the helm of the brewery until his death in 1781. During this time he followed in his father's footsteps by becoming MP for Southwark, from 1765 until he lost the seat in 1780, and alongside his wife, Hester, became rich, powerful and very well connected.

Henry married Hester in 1763. She was a charismatic woman, a talented wordsmith and a generous patron of the arts (a dinner held at the brewery in 1773 was attended by Goldsmith, Garrick, Burke and Sir Joshua Reynolds). It was this generosity, both financial and of spirit, that seems to have brought the Thrales and the celebrated lexicographer Dr Samuel Johnson together.

Johnson, a giant of Georgian letters, became a close friend of the Thrales, in particular of Hester. Johnson spent some seventeen years living with the Thrales and had separate rooms at both their dwelling within the Anchor and also their country estate in Streatham. He also accompanied them on their travels through Wales in 1774 and France the following year. On the latter trip the Thrale party were admitted to the court of King Louis XV and Marie Antoinette.

When Henry Thrale died in April 1781, Johnson was named as one of the executors of his estate. Hester was the main beneficiary and the decision was quickly taken to sell the brewery. An auction was held on 31 May 1781, just a month after Thrale's passing.

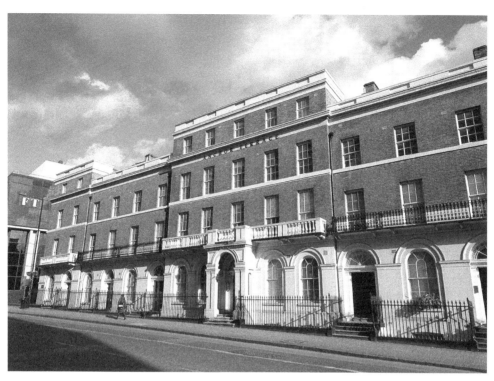

*Above and below*: Houses in Anchor Terrace, which were formerly offices for Barclay Perkins. Nearby is Thrale Street.

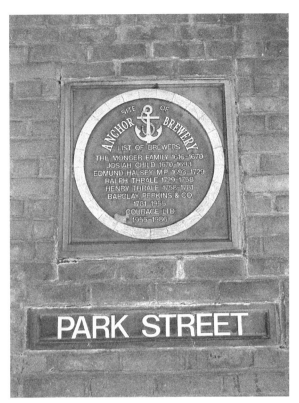

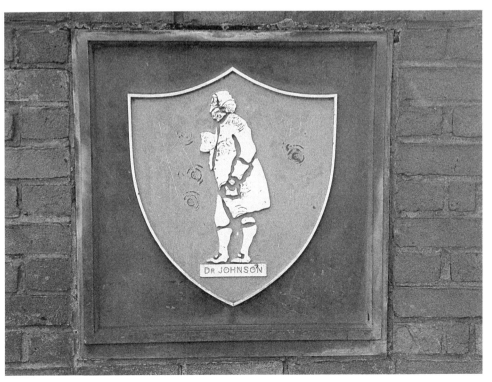

*Left, below and opposite*: A series of plaques mark the location of the Anchor Brewery.

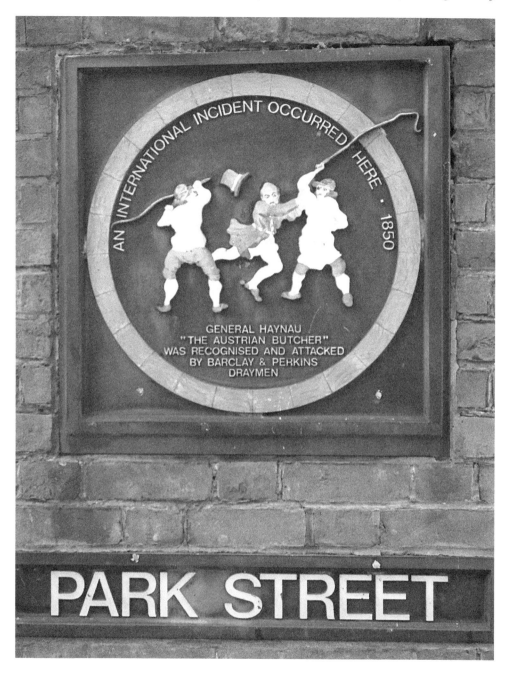

On the day of the auction, Johnson famously proclaimed, 'We are not here to sell a parcel of boilers and vats, but the potentiality of growing rich beyond the dreams of avarice.'

The business was bought for the then not inconsiderable sum of £135,000 by Robert Barclay, of the Barclays banking dynasty. John Perkins – who as chief clerk at Thrales had calmly pacified an angry mob intent on ransacking the Anchor during

the Gordon Riots of 1780 – became a partner, and the company was trading as Barclay Perkins by 1785.

As Barclay Perkins, output at the Anchor increased steadily, although they still trailed several breweries, notably the mighty Whitbread, in terms of output. That is, until 1802, when for the first time Barclay Perkins overtook their illustrious rival, producing some 137,463 barrels to Whitbread's 135,104 – although in the year in question both trailed the Horseshoe's 143,946 barrels. Barclay Perkins continued to grow and would soon, with the occasional blip, lead the field. Records show that in 1826 they brewed some 380,180 barrels and in 1867, 423,000, by which point they were the biggest brewer in the world.

The Anchor Brewery itself was by now huge, covering almost 10 acres of land, and had become one of the sights of London – a 'must-see' item on any visitor's itinerary. These included, over the years, Otto von Bismarck, Giuseppe Garibaldi and, in 1870, the French artist Gustave Doré, who famously made some drawings of brewery staff.

On 4 September 1850, a particularly memorable visitor was the Austrian general Julius Jacob von Haynau. Haynau was widely known as the 'Austrian butcher' on account of his brutal leadership in battles against Italian revolutionaries in 1848 and Hungarian revolutionaries in 1849. Today he would be declared a war criminal.

Pudney, in *A Draught of Contentment*, recounts how Haynau signed the visitor's book before setting off around the Anchor. However, news of his arrival was by now known throughout the brewery, and the cry of 'Down with the Austrian butcher' soon reverberated throughout the workforce, in particular from the draymen. It was these drayman, joined according to one report by equally angry local residents, who eventually caught up with Haynau. They made it clear in no uncertain terms that he was not welcome, attacking him with brooms and hurling mud and manure at him. A bale of hay was dropped on him and some of his clothes were ripped off by angry hands.

Haynau just about managed to escape a lynching on that fateful day, although his dignity was beyond retrieval. At one point during his pursuit he hid in a dustbin, and his life was probably saved by a passing 'police rowing galley'. One newspaper of the day, the *London Daily News*, reported:

> We rejoice that he escaped without serious injury, but we do also sincerely rejoice that such a manifestation of British feeling, so honest, so popular, and so spontaneous, as well as so energetic, goes forth to the world of Europe to mark in what estimation the deeds of Austria or Hungary are regarded by the intelligent of our industrious classes.

In 1955 Barclay Perkins merged with Courage, their brewing neighbour at Horsleydown. The two companies had previously discussed such a deal in 1939. In the post-war years, however, as both faced declining sales, it seemed to make sound business sense and they became Courage, Barclay & Co. The deal sadly marked the beginning of the end for the Anchor Brewery, and by 1957 only lager was being brewed here (in 1922 Barclay Perkins had been one of the earliest British brewers of lager).

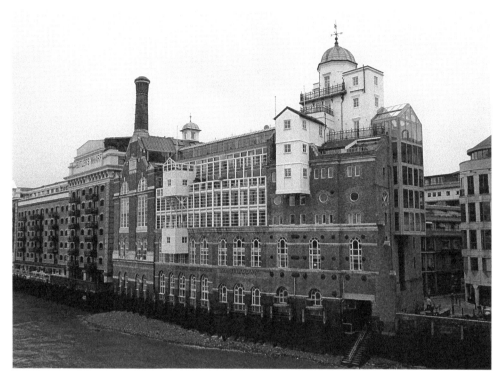

The Anchor Brewhouse today. It is now luxury apartments.

Much of the existing brewhouse was demolished to make way for a new bottling line in 1960, but brewing ended for good two years later.

With all production transferred elsewhere, the brewery was finally demolished in 1981, and most of the site was developed into housing. A walk around the area today reveals tantalising signs of its rich brewing past. Plaques in Park Street and the aptly named Porter Street commemorate the Anchor Brewery, the visit of Haynau and also Dr Samuel Johnson. For many years an image of Johnson featured as a Barclay Perkins' trademark.

On Southwark Bridge Road, Anchor Terrace can still be found, a Grade II listed procession of grand townhouses built in 1834 to house senior Barclay Perkins employees. In later years they acted as brewery offices.

## Take Courage

In 1787, John Courage, a Scot of French Huguenot stock working across the river in Wapping as a shipping agent, bought from the Ellis family a small brewhouse located on the banks of the Thames in the old parish of St John Horsleydown. Courage's first brew was a meagre fifty-barrel run. When Courage died just a decade later, with his son John only three-years-old, Courage's widow enlisted the help of John Donaldson, a senior brewery clerk, and the company traded as Courage & Donaldson until becoming in 1888 Courage & Co. By this stage they were brewing 300,000 barrels per year.

It was under the leadership of John Courage Junior, and later still his son, also named John, that the groundwork was laid to transform Courage into a brewing giant.

The second John Courage died in 1854, but this did not hamper growth. In 1860 a 35 hp steam engine was installed and in 1871 the brewery was rebuilt. Between 1893 and 1895 it was much altered to give us the quirky structure that survives today, largely the work of architects Inskip and McKenzie.

Following the 1955 merger with Barclay Perkins, there was another in 1960, this time with the Reading-based brewer Simmons to become Courage, Barclay, Simmonds & Co. In 1970 the company once again became simply Courage & Co.

The Anchor Brewhouse closed in 1982, with production moving to Reading, and in the mid-1980s the buildings were converted into a number of very expensive 'loft-style' apartments. The ownership of Courage has changed hands many times in the years since leaving London, and as of 2017 the brand was owned by Marston's.

There are still traces of Courage in London, including a number of very ornate pub exteriors that have somehow survived. A stroll around Horsleydown, meanwhile, is recommended. It remains a highly atmospheric area, one which is still very much dominated by the towering Courage brewhouse. Another reminder of the company is the Anchor Tap public house in Horsleydown Lane. As the name suggests, this was once the Anchor Brewhouse tap, but is today a Samuel Smith establishment.

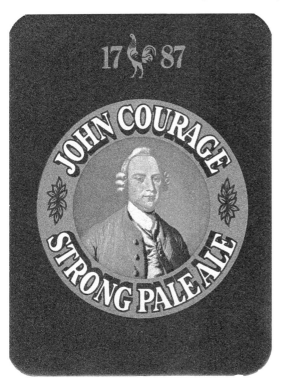
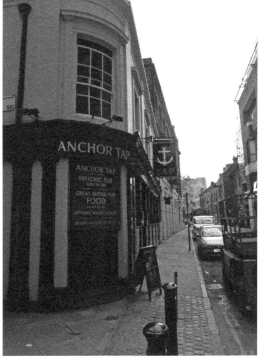

*Above left*: Beermat depicting the brewery's founding father.

*Above right*: The Anchor Tap, Horsleydown Lane.

*Above*: A fine example of surviving Courage livery at the Exmouth Arms, Finsbury.

*Right*: The Lion Brewery in 1939 and one of its two surviving Coade stone lions.

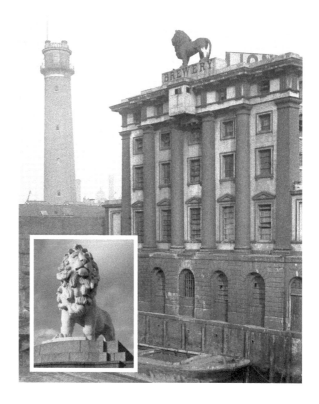

## Lion Brewery

The Lion Brewery, Lambeth, wasn't around for very long, but has left a very quirky mark on the capital. It opened in Belvedere Road, beside the Thames, towards the end of 1836, its imposing brewery buildings facing onto the river and featuring two magnificent and ornate sculptured lions. The Goding family were behind the original venture, which seems to have had a troubled existence for much of its life.

It was bought by Hoares in 1923 and production at Belvedere Road ended the following year. After being used as a storage depot, the building was demolished in 1949 as part of the project to clear this stretch of the south bank for the Festival of Britain in 1951. Today's Royal Festival Hall stands on the site.

When the demolition crew moved in, the two stone lions were saved. Made of Coade, an artificial stone, the larger lion was removed to the famous rugby stadium at Twickenham, while the smaller one was transported to a podium at the southern end of Westminster Bridge. Both survive to this day.

## Family Affair

The family behind the South London Brewery, set up around 1760 and based in Southwark Bridge Road, were the Jenners, although it was not until the 1930s that there was a change of name as the company started trading as R. H. Jenner & Sons. They merged with North London brewer Woodhead's in 1944, although within two years Woodhead's was the dominant trading name. In 1965 the company was bought out by Charrington.

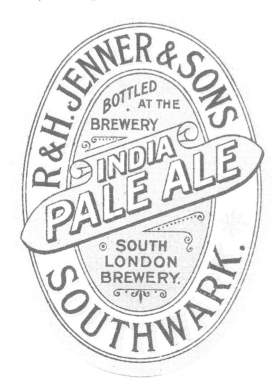

Label for Jenner & Sons IPA.

Many generations of the Jenner family have been involved in brewing, and it is reassuring to note that Miles Jenner, directly descended, is today joint chairman and head brewer at Harvey's Brewery in Sussex.

## Hop Exchange

It seems only apt given the historic concentration of brewing in the stretch of Southwark by the Thames that the rather grand Hop Exchange, which opened for business in 1867, can be found in Southwark Street.

Many hops from the county of Kent, historically regarded as the finest in England, arrived in London by road, river and, later, train. Stored in warehouses in the Southwark area, the Hop Exchange acted as a central marketplace for London's many brewers. It ceased trading in 1920 following a fire, but remains as a monument to an industry that once dominated this part of the capital.

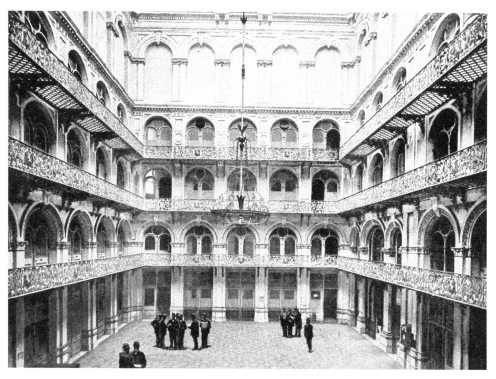

The Hop Exchange, 1897.

# 3
# East End Brewers – A River of Beer

'The sweetest beer in London.'
Claim made for Mann's
Original Brown Ale

Another of London's historic brewing hubs can be found in an area to the east of the City. We have already looked at the history of the Red Lion Brewery in East Smithfield, but there were several other major operators located in this part of the capital, perhaps the most famous of them all being Truman, Hanbury & Buxton, who from their sprawling Black Eagle Brewery in and around Brick Lane, once dominated London brewing.

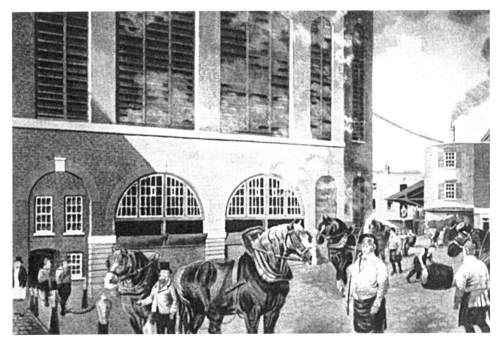

The Black Eagle Brewery, mid-eighteenth century. (Truman's)

Truman were always proud to claim 'London brewers since 1666', and there was certainly a brewing operation in this part of London, set up by Thomas Bucknall, in the year of the Great Fire. In 1694 the business was acquired by Joseph Truman, with Benjamin Truman joining the company in 1722. After Joseph Truman's death,

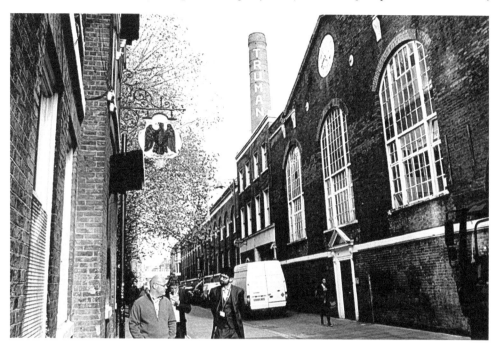

*Above*: Brick Lane today. (Truman's)

*Below*: Sir Thomas Fowell Buxton and the Brick Lane blue plaque in his honour.

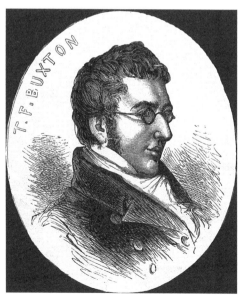
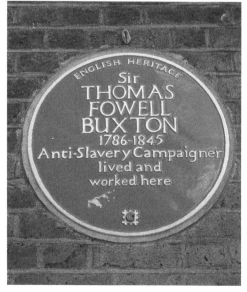

Ben Truman, as he was more commonly known, drove the business on to great success. He was knighted by George III in 1760 – Truman produced 60,140 barrels of porter that year – and had his portrait painted by Gainsborough. Make no mistake, here was a wealthy man, well connected and not without influence.

Upon Sir Benjamin's death in 1780 Sampson Hanbury became a partner. In 1808 his nephew, Thomas Foxell Buxton, joined the company, and so Truman, Hanbury & Buxton was effectively created. Buxton was, by all accounts, a gifted young man, driven but also public spirited and enlightened. He was a leading figure in the fight to abolish slavery, a fact marked by a blue plaque in Brick Lane. He set about instigating a number of changes in working practices at the brewery, and also provided funds to educate illiterate members of the workforce.

## Brewing Giant

Over the years, the Black Eagle Brewery grew, and was still being added to as recently as 1977, coming to dominate the local area. Although brewing ceased here in 1989, in many ways it still does. The old brewery chimney survives and has become something of a local landmark over the years. According to Mick Brown's *London Brewed*, in 1866, when the company was visited by the Prince of Wales, they were getting through '900 tons of hops' a year with some '3,000 pockets' kept 'ready for use' at any one time. They also had storage space for '100,000 barrels' and were producing around half a million barrels a year. In 1873 they bought out the Phillips Brewery in Burton and became the biggest brewer in the world.

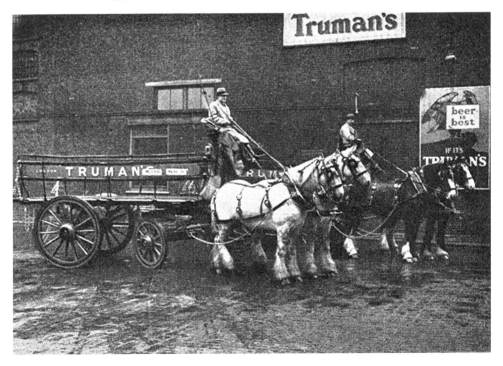

A Truman's dray. (Truman's)

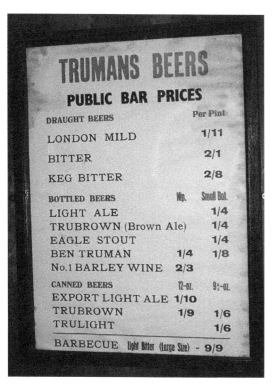

*Above and below*: Truman's have left their mark all across London.

The brewery site covered 10 acres of land and the second volume of *A History of the County of Middlesex*, published in 1911, regaled readers with some amazing statistics. The malt stores, for instance, were contained 'within a building 200 feet long, 30 feet wide and 60 feet high', while the brewing liquor was drawn from 'a well bored to a depth of 850 feet'. Chaim Bermant in *London's East End – Point of Arrival* reckoned that the brewery was 'almost a small town', with its 'own cooperage, wheelwrights, farriers, carpenter's shop, paint shop and artists' studio'.

As the bigger brewing concerns continued their predatory acquisition of smaller companies into the twentieth century, Truman snapped up a number of companies themselves. But during the 1950s and 1960s, the British brewing landscape was changing, as indeed were British drinking habits. In 1970 Truman signed an agreement to brew the Danish lager Tuborg under licence, and around this time also, effectively, stopped brewing cask ale.

## Takeover Frenzy

The following year Truman went from predator to prey when it became the subject of a takeover bid from the Grand Metropolitan pub and hotel chain. Fellow London brewer Watney's, who had long targeted Truman, promptly launched their own bid, which initially looked to be an acceptable one for the Truman board. What followed, however, was an amazing series of bids from the two companies, each larger than the previous one, until Grand Met finally prevailed.

Like many of the larger brewers, the seemingly relentless march of keg led to some pretty insipid beer rolling out of Brick Lane throughout the 1970s, although by the early 1980s Truman had returned to cask ale, notably with the formidable Sampson Extra Strong bitter. They also still retained a major pub presence, especially in London, where their distinctive livery often made for the most handsome of hostelry.

However, in 1989, after more than 300 continuous years of production, the Black Eagle Brewery fell silent with the loss of more than 200 jobs, and one of the most famous names in brewing history disappeared. But, as we shall see later, this is one London brewing story with a happy ending.

## Brown Ale

You don't have to travel far from Brick Lane to be reminded of two other former London brewing giants, namely Mann, Crossman & Paulin and Charrington.

The Blind Beggar pub in Whitechapel Road is best known today as the place where, in 1966, Ronnie Kray shot George Cornell. In a previous life, however, this was the brewery tap of Mann, Crossman & Paulin, one of London's best-known brewers and also the producers of a beer that was once famous the world over – a truly iconic brand that is still with us today.

There's a record of the Blind Beggar here in 1654, a tavern with its own brewhouse, but it wasn't until 1808 that large-scale production started in a brewery built by Richard Ivory. The following year it adopted the Albion Brewery name and changed ownership several times before, in 1823, Phillip Blake and James Mann went into partnership. Mann bought Blake out three years later, and when Mann died in 1844, his sons continued the business.

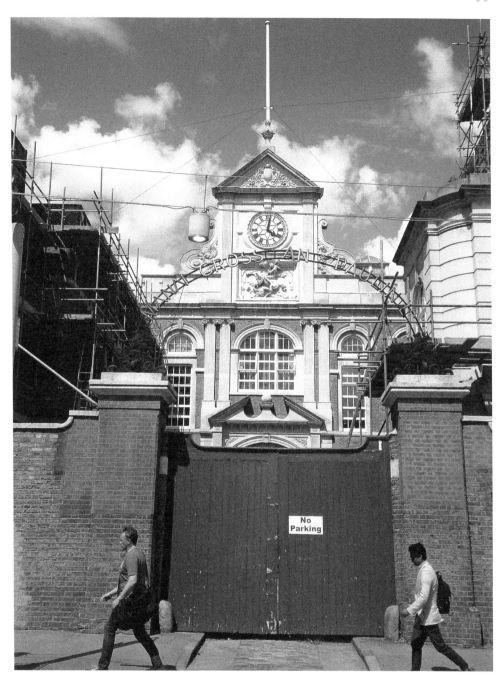

The entrance to the Albion Brewery, Whitechapel.

In 1846 Robert Crossman bought 25 per cent of the company with William Paulin also joining. Soon they were trading as Mann, Crossman & Paulin, producing porter for the masses in vast quantities. The brewhouse was improved and enlarged in 1863, and in the mid-1870s they expanded out of London, setting up a second Albion Brewery in Burton upon Trent. The Blind Beggar was rebuilt in 1894.

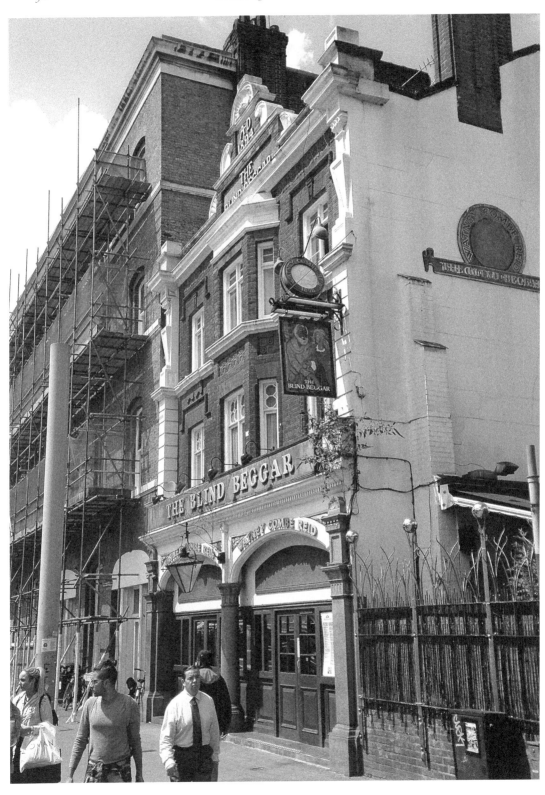

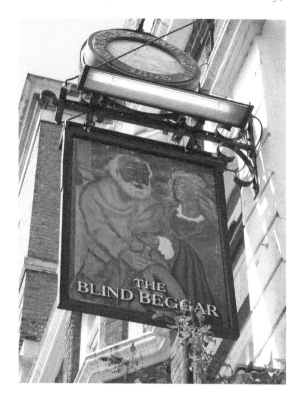

*Right and opposite*: The Blind Beggar was formerly the Mann, Crossman & Paulin brewery tap.

A rare surviving Mann, Crossman & Paulin window at the Three Kings, Clerkenwell.

The company merged with Watney's in 1958 and brewing stopped at the Albion Brewery in 1979. Fragments of the brewery still survive, including the main entrance.

However, it is for one particular brand of beer that the company will always be remembered, namely Mann's Original Brown Ale. A bottled beer, it was developed by the company around 1902, possibly a year or two earlier, and was the brainchild of head brewer Thomas Wells Thorpe. The term 'brown ale' was not a new one, and the Mann's version was essentially a bottled mild. It was marketed by the brewery as 'the sweetest beer in London' and after a slow start became a huge seller, often used as a mixer to liven up draft beer lacking condition. A pint of 'brown and mild' remained a popular drink well into the 1960s.

Mann's Original Brown Ale is still produced today, brewed by Marston's in Wolverhampton. It has an ABV of just 2.8 per cent. The late Michael Jackson included it in his seminal *Great Beer Guide*, describing it as, 'Smooth and creamy, with flavours of chocolate-coated raisins.' Roger Protz, in *300 Beers To Try Before You Die*, reminds us that it was the drink of choice for Mr Creosote in Monty Python's *The Meaning of Life*. Mr Creosote, you might recall, eventually explodes.

## Charrington

On the corner of Mile End Road and Cephas Avenue you'll find an elegant Grade II listed building, dating from 1872. This was the company offices of Charrington and is all that remains of the Anchor Brewery.

Records suggest brewing on this site had been going on since the early eighteenth century, originally in the White Horse Tavern and later at the Blue Anchor brewhouse. The Anchor Brewery was established here in 1757. Robert Westfield and Joseph Moss were at the helm until 1766, when John Charrington bought a third of the company, which became Westfield, Moss & Charrington. Westfield died in 1776 and Moss stood down in 1783, from which point the Charrington family were in control.

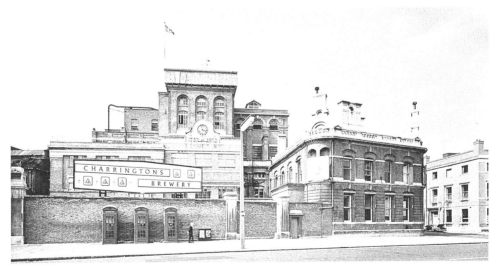

Charrington's Anchor Brewery, 1973. (London Metropolitan Archives, City of London)

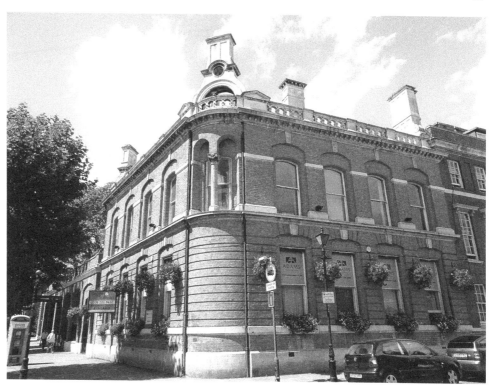

*Above and below*: The old Charrington offices today, and the Anchor Retail Park, on the right.

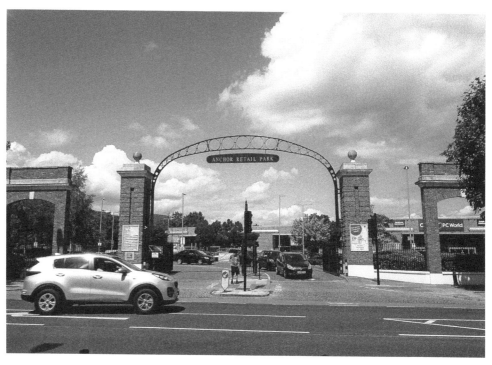

Steam power was introduced in 1828 as production rose. The company had been ale brewers but in 1833 they started brewing stout and, surprisingly late all things considered, porter. Generations of the Charrington family would successfully run the company, swallowing up smaller concerns along the way. Throughout the twentieth century Charrington continued their policy of acquiring smaller brewers, including Brooks of Peckham in 1916 and a stake in Hammertons of Stockwell in 1951.

But not all of the Charrington family were happy to be associated with the brewing industry. Frederick Nicholas Charrington, destined to one day inherit the firm, was walking through Whitechapel one day when he witnessed an altercation between a husband and wife outside a public house. The woman was imploring her husband to leave the pub so that the family might have some money left for food, but instead she was knocked into the gutter by her intoxicated spouse. To the young Frederick's horror, the public house to which the husband returned was a Charrington hostelry.

## Taking the Pledge

This was too much for young Frederick, nineteen at the time. He promptly took the pledge and would become a leading figure in the Temperance Movement. In 1873 he sold his share of the business, worth more than £1 million. After this, according to Bermant's *London's East End*, Frederick Charrington set out to 'spread the word of Christ, to check the torrent of alcohol' and to make Britain in general and 'East London in particular a "purer" place to live'. Charrington lived the rest of his life in Stepney Green and died at the London Hospital in 1936.

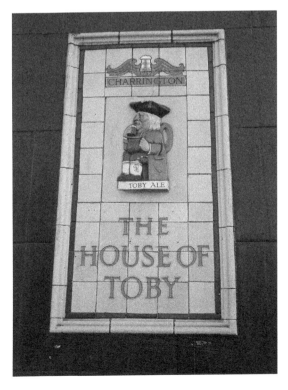

Charrington were the third brewer to adopt the Toby Jug trademark.

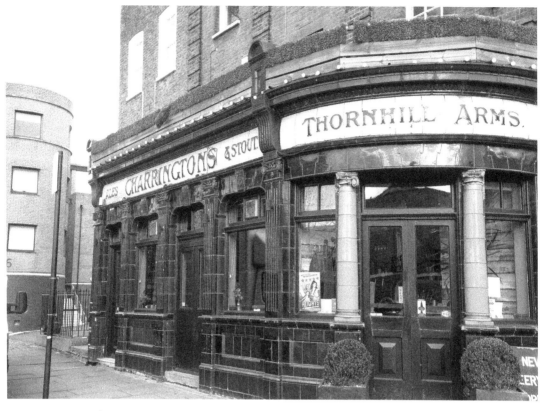

Surviving Charrington pub livery, Caledonian Road.

The company that bore his name, meanwhile, went from strength to strength. In 1962 Charrington merged with United Breweries to form Charrington United Breweries, and in 1967 they merged with Bass, Mitchells & Butlers to form Bass Charrington. With production increasing, it was clear that the old Anchor Brewery was no longer large enough, and in 1975 production stopped after more than 200 years of continuous brewing, although the company's offices remained for some time after. The site of the brewery itself is now mostly occupied by the aptly named Anchor Retail Park.

## Taylor Walker

Although in historical terms it seems to languish in the shadow of several fellow East End brewers, Taylor Walker should be remembered as a major brewer in their own right. Operating from the famous Barley Mow Brewery in Limehouse, they were initially a successful porter brewer with a sizeable pub estate and substantial bottling operation. Brewing was certainly taking place at the Limehouse site by 1740. Brothers John and Richard Hare brewed here, possibly in partnership with James Salmon, although the Hare family seem to have been in total control by the 1780s. John Taylor joined in the early 1790s and Isaac Walker, connected to Taylor by marriage, joined in 1816. Taylor Walker, as a trading entity, seems to exist from this date.

Labels for Charrington's Family Stout, Oatmeal Stout and Barley Wine.

Labels for Mann, Crossman & Paulin and Taylor Walker.

By 1889 the Barley Mow had been rebuilt on a grand scale, swallowing up an area of land formerly occupied by the Limehouse Workhouse, and into the twentieth century the company continued to hold its own in a competitive and congested environment. In 1929 they bought the Cannon Brewery, Clerkenwell. This was a big acquisition in the scheme of things, and Taylor Walker would later adopt the Clerkenwell brewery's famous cannon logo.

However, the Barley Mow suffered considerably during the Blitz, and there was no brewing at all between March 1941 and August 1942 after damage inflicted by a German incendiary bomb. Taylor Walker merged with Ind Coope in 1959, and, after many months of rumour, production ceased at the Barley Mow in 1960. The brewery was later demolished and much of the site is now occupied by the Barley Mow Estate. Taylor Walker is now part of the Carlsberg Group.

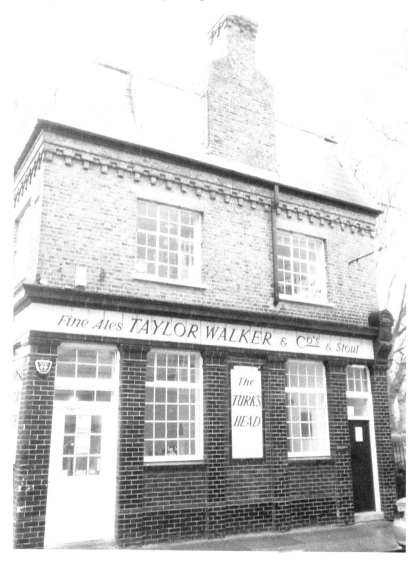

*Right and following pages*: Fine surviving Taylor Walker pub livery at the Turk's Head in Wapping.

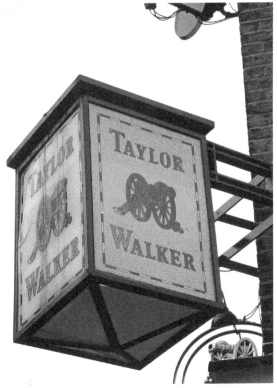

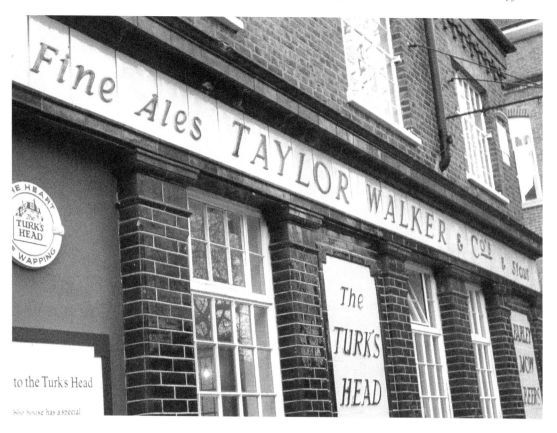

## India Pale Ale

Before we leave East London, for now at least, there is one more brewer of note to mention, namely George Hodgson. A small brewer in terms of output, certainly when compared to many others, George Hodgson & Co. were based in Bow, and according to *London Brewed*, were active as early as 1751.

Hodgson had the good luck to be located close to the Blackwell Docks, which were used by the all-powerful East India Company, and when they wanted beer to transport to the colonies, it was to local brewers they turned, including Hodgson. Hodgson provided porter to the East India Company from the late eighteenth century onward, but also pale ales of considerable strength and a high rate of hopping (both designed to help preserve the beer en route). As has been detailed elsewhere, this pale beer underwent a remarkable transformation on the long voyage to India and so, more by accident that intent, the beer history knows as India Pale Ale was created.

No doubt there were other brewers providing the East India Company with beer, but Hodgson is widely reckoned to be the first. What is certain is that he was the first to use the name India Pale Ale. Well done George.

# 4
# They Also Brewed – Watney, Whitbread, Fullers, Meux and Young's

'The carpenters and bricklayers belonging to the Trades Union have, in consequence of Messrs Combe and Delafield's refusal to employ any person connected with Trade Unions, resolved to drink no more of their beer.'

*The Times*, 5 April 1834

No book about the history of brewing in London can be complete without mention of Whitbread, a company that started modestly and rose to become one of the giants of British brewing. Be warned dear reader, this is a story without a happy ending.

*Left and opposite above*: Whitbread Brewery, Chiswell Street, with Hind Head symbol.

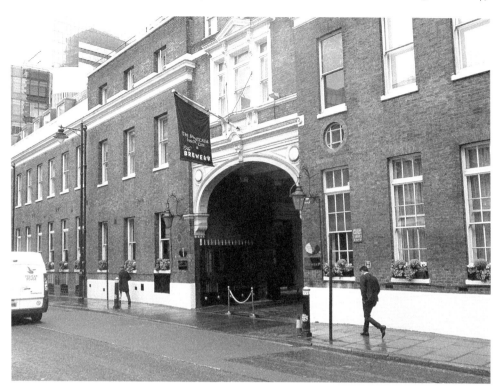

Old Whitbread stables in Garrett Street.

Samuel Whitbread was born and bred in Bedfordshire and arrived in London aged fourteen in 1734. He was apprenticed to John Wightman, Master of the Brewers' Company, where he learnt the ins and outs of the brewing industry. Having inherited a small sum, in 1742 the young Whitbread entered into partnership with the Shewell brothers, George and Thomas, and together they ran the Goat Brewery, on the corner of Whitecross Street and Old Street, in the parish of St Luke's.

In 1749 the company moved the short distance to Chiswell Street after acquiring the disused King's Head brewhouse. Brewing had been going on here since the late seventeenth century. A new brewery was built on the same site, opening for the brewing of porter in 1750, and within ten years they were trading as Shewell & Whitbread, producing more than 60,000 barrels a year. The brewery's famous Porter Tun Room dates from 1760 and the following year Whitbread assumed total control of the business, buying out the Shewells.

Whitbread soon put his own stamp on the business. In 1785 they were among the first brewers to introduce steam into the production process, enlisting the services of engineer John Rennie to install a 'stupendous steam engine' designed by Boulton & Watt. This, according to the 1951 book *Whitbread's Brewery*, was 'one of the wonders of London'. It did the work of fourteen horses and was used to grind malt and 'raise' the liquor. Two years later the brewery was visited by King George III and Queen Charlotte.

## Visitor Attraction

The Whitbread Brewery had grown so vast that it became something of a tourist attraction in its own right. It featured in 1802's *The Union Magazine and Imperial Register*, where it was described as, 'The greatest [brewery] in London. The commodity produced in it is also esteemed to be of the best quality of any brewed in the metropolis.'

*The Union Magazine* is a valuable source of information regarding Whitbread in the early nineteenth century. It tells us, for instance, that the brewery was producing some 200,000 barrels of porter a year. Good porter needed a lengthy period of maturing, and so,

> There is one stone cistern that contains 3,600 barrels, and there are 49 large oak vats, some of which contain 3,500 barrels...There are three boilers, each of which holds about 5,000 barrels...

These stone cisterns were not initially successful as the beer leaked through the walls. An engineer called John Smeaton was called in to solve the problem, which in time he did. He would later go on to design the Eddystone Lighthouse.

In 1812 Whitbread and the Lambeth brewer Martineau & Bland joined forces, with John Martineau becoming a partner. In 1834 Martineau was found dead in the Porter Tun Room. He had fallen into a tank of spent yeast and an inquest decided that he had, 'Died by the visitation of God.'

All things considered, 1834 was a pivotal year for the brewery, for it also marked their move from exclusively brewing porter and stout into pale ale production. Whitbread finally stopped brewing porter altogether in 1941 – a reflection of the changing taste of the British beer drinker.

## Final Brew

A central factor in Whitbread's continued growth over the years was their often ruthless acquisition of smaller regional breweries. In 1928 they acquired a substantial stake in the Mackeson brewery of Hythe in Kent, for instance, and started to brew the eponymous Milk Stout themselves. In 1961 around half of Whitbread's total output was Mackeson's Milk Stout. So veracious was the company's takeover policy that the Campaign for Real Ale produced a T-shirt bearing the legend 'Whitbread – Tour of Destruction'.

The Chiswell Street Brewery had survived the Blitz, thanks in no small measure to the company's own in-house fire fighting force, and Whitbread appeared to be a company proud of their history, their workforce and, indeed, of what they produced. This was reflected in a series of books published just after the Second World War, including titles such as *Whitbread Craftsmen, The Brewer's Art,* and a short history of the company, *Whitbread's Brewery.*

But times change, and in April 1976, after more than 200 years of continuous brewing, the final gyle of beer was produced at Chiswell Street – a batch of pale ale. It was the end of an era, for although the company would continue to use the site as their administrative base, and their mighty dray horses remained nearby in their Garrett Street stables well into the 1990s, there was no going back.

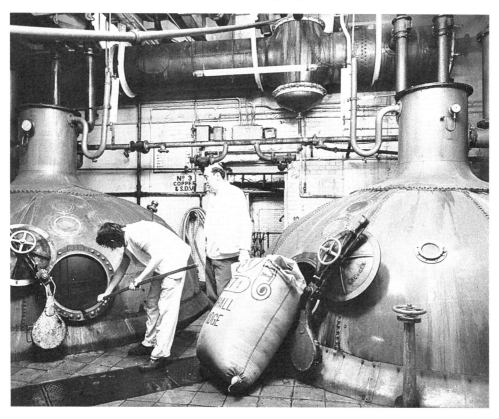

Hops go into the copper at Whitbread for one of the last ever brews in 1976. (London Metropolitan Archives, City of London)

*Above and below*: A selection of books published by Whitbread in the 1940s and 1950s.

Commemorative beer produced in 2018 to mark 275 years of Whitbread.

By the year 2000 Whitbread had offloaded all of their brewing interests to Interbrew, now InBev, and today, as Whitbread plc, their core business is coffee shops and budget hotels. However, in 2018, to mark the 275th anniversary of the company, they produced a limited edition bottle-only beer called 1742. It was brewed by the Black Sheep Brewery and was infused with coffee.

## Clerkenwell

Just a few minutes from Chiswell Street is the historic area of Clerkenwell. Over the years several breweries have been based here, including two of particular interest.

The Cannon Brewery is recorded in St John Street around 1750, controlled by the Dickinsons. Generations of the family were involved with the brewery until the 1820s, when the Gardener family took control. They sold it on in 1863, when it was bought by the partnership of George Hanbury and Barclay Field, and by 1876 it was trading as the Cannon Brewery. The late nineteenth and early twentieth centuries marked a period of expansion for the company, who grew their pub estate substantially. Their famous cannon logo became a familiar sight across the capital.

In 1930 the Cannon Brewery was bought by Taylor Walker, who appropriated the cannon trademark as their own. Brewing ended at St John Street in 1957, and although much of the extensive complex of buildings have been sadly lost the magnificent entrance in St John Street itself has survived.

Part of today's Clerkenwell Road was once known as Liquorpond Street, and here stood the Griffin Brewery, set up in 1762 by Richard Meux and Mungo Murray. In 1793, Murray having departed, Meux was joined in partnership by Andrew Reid, and as the nineteenth century neared the company emerged as one of London's foremost porter brewers. Meux departed in 1798, leaving his sons, including Henry, to take his place.

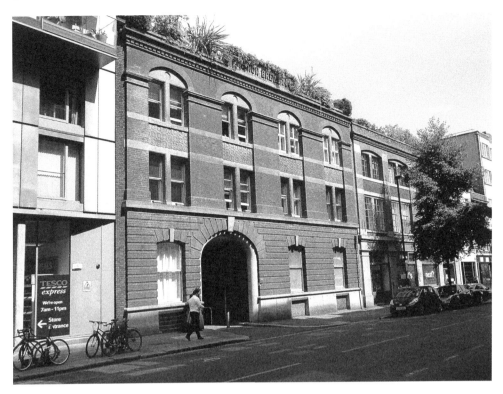

*Above and left*: The main building and gateway of the Cannon Brewery, Clerkenwell.

A surviving part of Reid's Griffin Brewery, Clerkenwell.

In 1807 there was much acrimony among the partners and Henry Meux departed, moving to the Horseshoe Brewery in Tottenham Court Road. Soon after, the Griffin started trading as Reid's. In 1898 they merged with Watney and Combe to form Watney, Combe & Reid, and brewing ceased at the Griffin the following year, with much of the 3.5-acre site being turned over to council housing. The Griffin pub, the former brewery tap, survives in Clerkenwell Road, while part of the brewery buildings can still be seen in Hatton Garden, complete with the brewery's famous old Griffin insignia.

## Great Beer Flood

The Horseshoe Brewery had been established in Tottenham Court Road by 1764, and it was here that Henry Meux revived his brewing career after his departure from the Griffin. The company was famed for the quality of its porter, but is perhaps best remembered for the great London beer flood of 1814.

Porter was brewed on a huge scale at the Horseshoe, and this in turn meant vats of gargantuan proportions. Such a vat stood 22 feet high and contained some 3,555 barrels of porter, more than 1 million pints of beer. On 17 October 1814 this vessel ruptured, disgorging its torrent of ink-black beer. This in turn destroyed several other vessels in a devastating domino effect. In total around 3 million pints flooded the brewery and the surrounding streets.

Surrounding the Horseshoe brewery was the rookery of St Giles, one of the poorest parts of London, and in the ensuing deluge eight people lost their lives and many buildings were destroyed, including the Tavistock Arms public house.

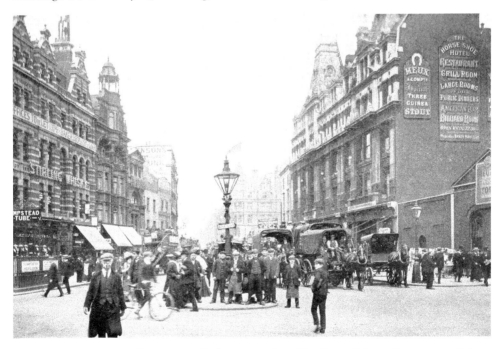

Tottenham Court Road, 1910, with the Horseshoe Hotel and Meux Brewery on left.

The great beer flood not only caused devastation but also equalled financial disaster for Meux & Co., who had already paid duty on the lost beer. Facing ruin, they made an application to Parliament and managed to reclaim the duty. This gave them time to rebuild and regroup, and the Horseshoe continued to brew until 1921, when production was moved to the Thorne Brothers Brewery in Nine Elms. The Dominion Theatre now stands on the site of the Horseshoe Brewery, although the old Horseshoe Hotel and the old brewery tap remains, now, alas, as shops and offices.

## Watney, Combe & Reid

For many drinkers the name Watney is synonymous with Red Barrel, a beer originally launched in the early 1930s that would later come to represent for cask beer lovers all that was wrong with filtered and pasteurised keg beer. Indeed Red Barrel, later rebranded simply as Red, became something of a laughing stock in beer circles, ridiculed by drinkers and comedians alike, most famously the Monty Python team. That didn't stop it selling, mind you.

It is a shame that Watney – or Watney, Combe & Reid to give them their full name at the time – are remembered for this dreadful drop, because their roots can be traced back to the early seventeenth century and the very early days of London's developing brewing industry. The Greene family emerge as central to the brewery's early history and were possibly involved with the ancient brewhouse that once operated at Westminster Abbey. Thomas Greene was Master of the Brewers' Company in 1420.

By the early seventeenth century, a brewhouse known as the Stag was operating in and around the Victoria area, centred on today's Castle Lane, then known as Cabidge Lane. In 1715 it was completely rebuilt by William Greene. In his book *The Red Barrel*, Hurford Janes writes that the brewhouse was '111 feet long and 83 feet wide', while 'the Pale Brew House' was '110 feet by 40 feet'.

It is testament to how the brewery grew over the years that by the end of the eighteenth century it covered an area of more than 16 acres. It was a considerable industrial operation in the heart of Westminster, covering land bordered by today's Frances Street, Vauxhall Bridge Road, Victoria Street and Castle Lane. William Stow, writing in 1722, reckoned it to be the 'finest brewhouse in Europe'.

## Merger

The Watney family became involved in the 1830s and by the late 1880s the company was one of the biggest London brewers, but in a congested marketplace the age of merger and unification was already at hand. In 1898 Watney joined forces with two other brewers, Combe's of Covent Garden and Reid's of Clerkenwell, and Watney, Combe & Reid was born.

Combe's started life at the Woodyard Brewery. The site near Long Acre was originally a timber yard and the founder, Thomas Shackle, seems to have combined the business of making beer with that of making barrels. It was taken over by the Gyfford family around 1750 and they developed it into one of London's major porter breweries. In 1787 it was bought by Harvey Christian Combe. Under his tenure what

would become known as the Royal Brewhouse Dinner took place in 1807, a grand event attended by, among others, the Duke and Duchess of York, and held in the brewhouse itself. Cloth from hop pockets was used as tablecloths, and apparently the only drink available was porter.

When Combe died in 1818 the business was taken over by his son, also named Harvey, and his brother-in-law, Joseph Delafield. The company traded as Combe & Delafield until 1866, when it became simply Combe & Co. They were involved in some industrial unrest throughout 1834, and a notice appeared in *The Times* that read: 'The carpenters and bricklayers belonging to the Trades Union have, in consequence of Messrs Combe and Delafield's refusal to employ any person connected with Trade Unions, resolved to drink no more of their beer.' It was a charge denied by the company, but it did confirm that while the people running London's breweries were powerful and influential, the people drinking most of their beer were from the working classes. Brewing continued at the Woodyard Brewery after the 1898 merger until its closure in 1905.

Watney, Combe & Reid would continue to be one of London's best-known brewers throughout the twentieth century, although there was another merger in 1957 with Mann, Crossman & Paulin of East London. The new company became Watney Mann, although in time it became widely known simply as Watney's.

There was no room at the Stag Brewery, Victoria, for redevelopment, so in April 1959 the last brew took place and demolition soon followed. Production was transferred to Mann's Albion Brewery in Whitechapel and the Stag Brewery in Mortlake.

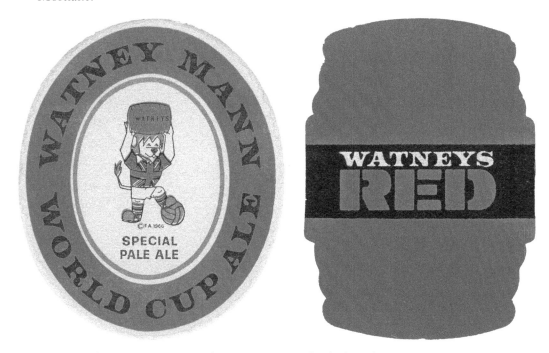

*Above and opposite*: Beermats from Watney's and Whitbread.

*Above and opposite*: Beermats from Truman, Courage and Young's.

## Fuller's

While all of the giant London breweries, one way or another, departed the capital during the post-war years, two smaller and independent brewers kept the good beer flag flying, namely Fuller's in Chiswick and Young's in Wandsworth.

The roots of what we now know, and indeed cherish, as Fuller's can be traced back to the 1680s, when Thomas Mawson started brewing in Chiswick, at first as an employee of the Urlin family. By the turn of the century he had managed to acquire the business for himself. By 1782 a man called John Thompson was in charge and in 1807 it passed to his sons, Douglas and Henry. However, they ran into financial problems and invited Philip Wood, a respected hop merchant, to come onboard. This he did, and in 1829 a partnership was formed between Henry Thompson, Wood and John Fuller. Described in *London Pride*, a history of Fuller's, as a 'country gentleman', Fuller would transform the company and in the process start a brewing dynasty.

In 1816, several years before Fuller's involvement, the company had adopted the Griffin Brewery name, although this wasn't granted as a trademark until 1892. The Griffin, of course, had been the sign of the old Meux and Reid brewery in Clerkenwell.

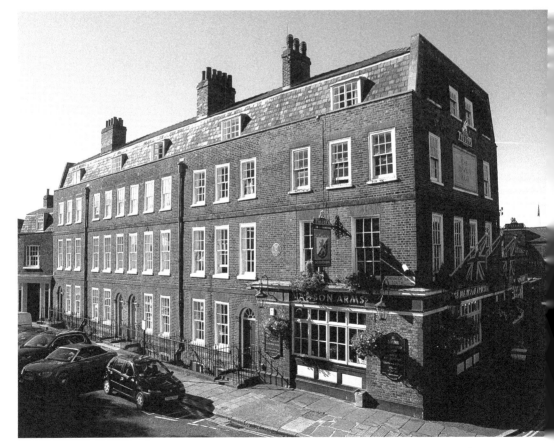

*Above and opposite*: Fuller's of Chiswick are London's only surviving major brewer.

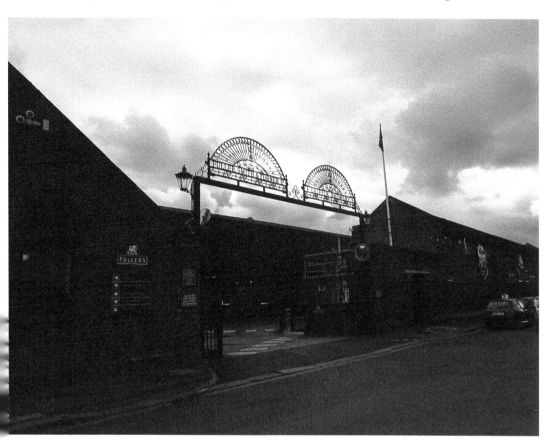

In 1841 Fuller's started brewing porter, and in 1845 Thompson was finally evicted from the company. John Smith soon joined Fuller as a partner and, in time, so did John Turner, who was Smith's son-in-law. Thus, Fuller, Smith & Turner was born.

While the big brewers were getting bigger, independent brewers such as Fuller's had to fight for survival. Early growth between 1855 and 1863 saw the brewery expanded with new stores and also a new tun room, and profits rose from £6,000 a year when the partnership was formed to £16,000 by the 1860s.

Using water drawn from a well some 400 feet deep, Fuller's beer had a good reputation among London drinkers, although it was to some extent still a drink favoured mainly by those to the west of the metropolis. In 1909 they bought the Beehive Brewery, Brentford, along with thirty-four public houses, although business suffered during the First World War and in 1917 they pooled resources with fellow local brewers, among them the Isleworth Brewery. This agreement ended with the Armistice of November 1918. In 1919 Fuller, Smith & Turner were finally registered as a private limited company.

In 1959 the brewery introduced London Pride, a classic session bitter that has since become their flagship and best-selling brand. It has also become an iconic London beer, and is one known the world over. They continue to thrive as a company, and in recent years have dipped a tentative toe into the world of craft beer.

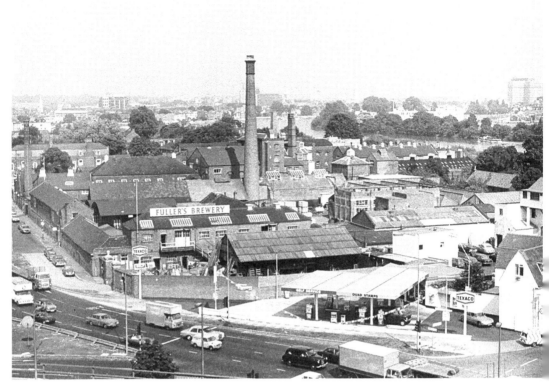

*Above and below*: Aerial shots of the Griffin Brewery in 1960 and today. (Fuller's)

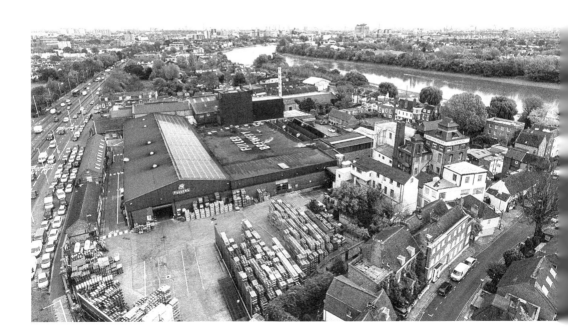

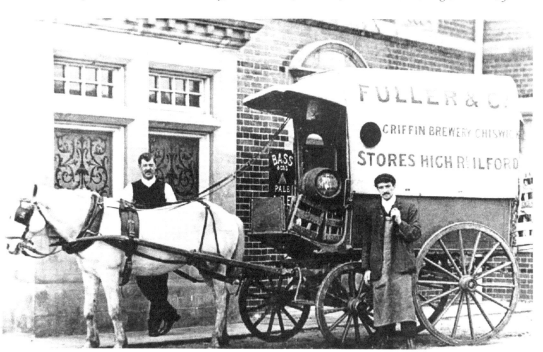

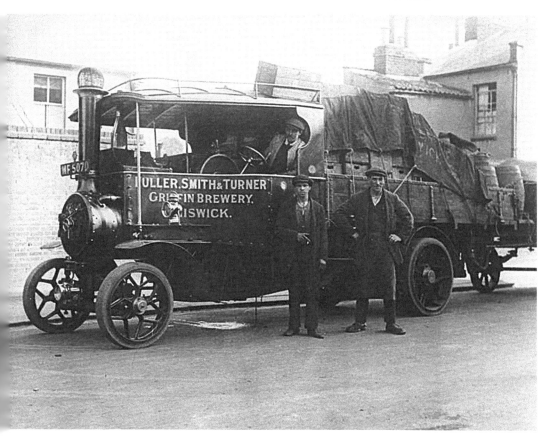

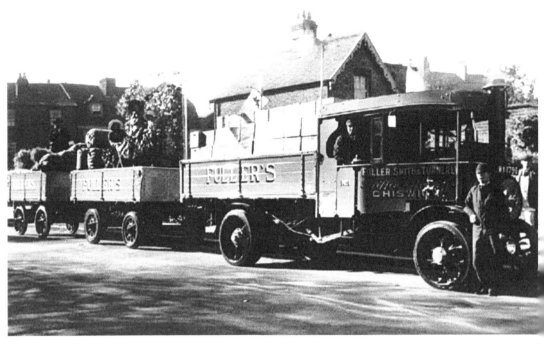

*Above, below and previous page*: Using a variety of different modes of transport, down the years Fuller's have quenched London's thirst. (Fuller's)

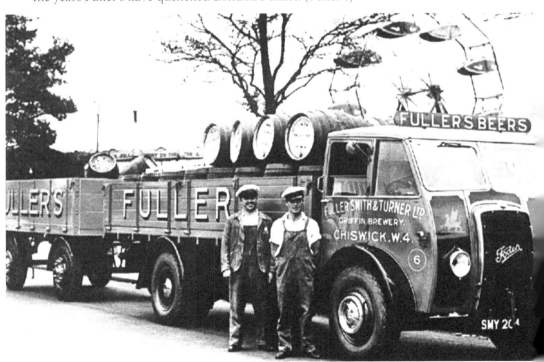

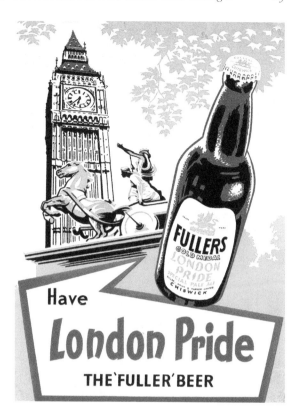

Fuller's launched their iconic London Pride in 1959. (Fuller's)

## Young's

While Fuller's were keeping the tradition of independent brewing alive north of the Thames, Young's of Wandsworth were playing their part just across the river. The company give a founding date of 1831, but it seems they were brewing before then. Certainly brewing had been going on at the Ram pub, later the site of the brewery tap, since the mid-sixteenth century.

The Draper family ran a brewery here from 1675, and many years later, around 1831, it was acquired by Charles Allen Young in partnership with Anthony Fothergill Bainbridge. They brewed mainly porter early on, and introduced steam power in 1835. A fire decimated the brewery in 1882 and it was largely rebuilt as a result. The Young family took complete control of the business the following year and it remained a family concern from then onwards.

There was major investment in the Ram Brewery during the 1980s, and with Young's 'ordinary' bitter widely recognised as one of London's best-loved beers, the future looked bright for the company. However, in 2006 the final brew was run off at the Ram, with production of Young's beers being transferred to Wells & Young in Bedford. To accommodate this arrangement a new company was created, Wells & Young, with Young's holding a 40 per cent stake to Charles Wells's 60 per cent. However, in 2011 Young's pulled out of brewing completely, selling their share of the business to Wells.

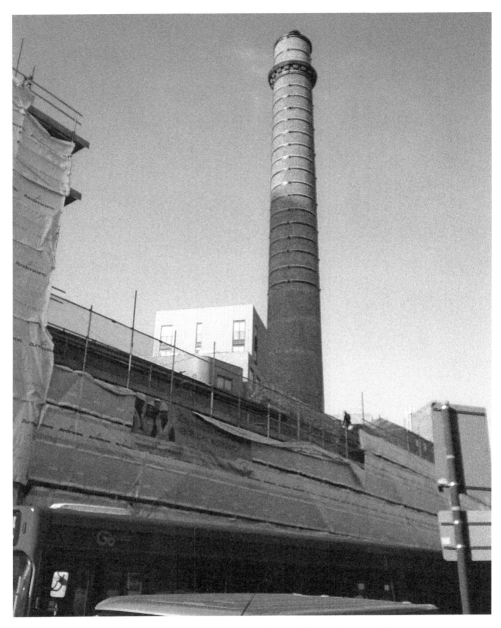

The former Ram Brewery is being redeveloped into flats, shops and restaurants.

Young's now exist as a pubco, although Young's beer is still brewed, these days by Marston's. The Ram Brewery, at time of writing, was being redeveloped as a 'high-quality mixed used scheme, unlocking a new urban quarter for Wandsworth'.

When production stopped in 2006, new owners Minerva enlisted the services of John Hatch, once a member of the Young's brewing team. Hatch has continued to brew on the site, albeit on a very small scale. This has enabled all concerned to maintain the claim that the site houses 'the oldest brewery in Britain'.

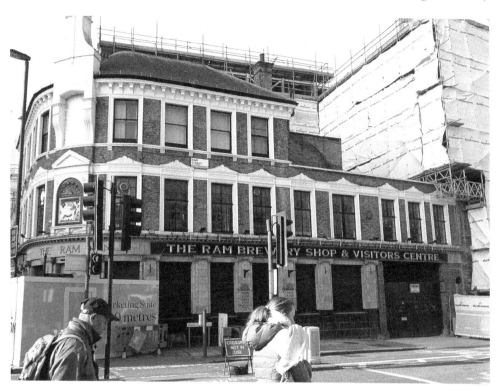

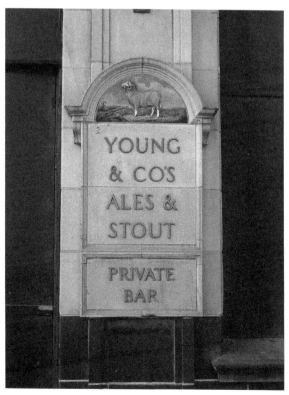

*Above and right*: The Ram pub, formerly the Young's brewery tap.

# 5

# The Death and Rebirth of Brewing in London

> 'I never wanted to work anywhere else but London.'
> Evin O'Riordain, the Kernel Brewery

The number of breweries in London had been in steady decline since the early nineteenth century, but at the beginning of the twentieth century brewing was still one of the capital's most important and high-profile industries. And it wasn't all closures, for in 1936 the massive Park Royal Brewery was opened by Guinness, remaining in production until 2005. Someone still had faith in London as a brewing location.

The capital still had twenty-five breweries in 1952, including Charrington, Courage, Mann, Paulin & Crossman, Truman and Whitbread. But times were changing, as were

*Above and opposite*: A host of new brewers have revitalised London's beer scene.

methods of mass production. The drinking habits of the nation were also changing, not to mention the nature of Central London itself. In the second half of the twentieth century it seemed more and more of an anachronism that an ancient industry such as brewing, with its attendant smell, noise and heavy traffic, was still located in the very heart of the mighty metropolis.

In an age of homogenisation, merger and takeover, there was no room for sentiment. Watney departed their spiritual home, the Stag Brewery, in 1959. Brewing had gone on here since the mid-seventeenth century, and maybe even earlier. But that counted for little. It was a clear indication of what was to come, and at the start of the 1960s there were just sixteen brewers left in Greater London.

## Major Closures

In 1960, five years after the merger of Barclay Perkins and Courage, brewing stopped at the deeply historic Anchor Brewery, although bottling continued here until demolition in 1981. There was surely something deeply symbolic, and very sad, that a site which had brewed continuously since the early seventeenth century had finally fallen silent.

In the following decade it would get worse. In 1975 the final brew took place at the Anchor Brewery, Mile End, and the unthinkable happened the following year when production ended at Whitbread's Chiswell Street Brewery. In 1979 the Albion in Whitechapel Road was closed and the same fate befell Courage's Anchor Brewhouse at Shad Thames in 1982.

As gloomy as the landscape looked towards the end of the 1970s, there was a breakthrough moment in 1977 when a young Londoner of Irish extraction called Patrick Fitzpatrick founded Godson's, a cask ale microbrewery based in Hackney. It was the first new London brewery in almost forty years. Although his beer was top class, the business of brewing itself was not for Fitzpatrick, and he sold his rights to the Godson's name. But what he had shown was that small could be beautiful.

## Bruce's Brewery

Although barely into his thirties, David Bruce was already a brewing industry veteran. He had worked for Courage and later for Theakston, but in 1979 found himself living in London and at a loose end career-wise. One day, while jogging, he passed a derelict and boarded-up pub in Borough Road, Southwark, and had a lightbulb moment.

Over the next few months, and with the help of loans from Bass Charrington and Kent brewer Shepherd Neame, Bruce transformed the not so grand old Duke of York, the pub's original name, into the Goose and Firkin. It was very much a return to pub basics, and perhaps most important of all it featured a five-barrel microbrewery squeezed into 'a space at the bottom of the stairs'.

The rest is history, for against all the odds the Goose and Firkin was an instant and huge success. Some purest complained about the use of malt-extract, but at the end of the day Bruce had brought small-scale brewing back to the capital.

Soon, Firkin pubs started cropping up all over London, their philosophy of stripped-down old-style interiors and ale brewed on-site proving popular with drinkers looking for an alternative to the bland beer that had become the preserve of the big breweries of the day.

While this was going on, there were other developments in the capital. In 1980 Simon Hosking set up the Tower Bridge Brewery at Number 218 Tower Bridge Road, a former rope factory that lent itself well to the classic tower brewery layout. The beer that Hosking, a founding member of the Society of Independent Brewers, produced was by all accounts pretty good, but problems breaking the big brewers' monopoly and getting the beer out to a wide enough market proved fatal. Eventually it turned sour at Bruce's Brewery too. In 1988 Bruce sold up, and after several changes of ownership the Firkin brand was eventually put out of its misery.

But despite these setbacks, it was clear that a new breed of brewer was starting to emerge. In 1982, in the basement of the now legendary Beer Shop in Pitfield Street, Hoxton, Brian Brett set up the Pitfield Brewery. In 1986 they moved to a bigger brewery just around the corner, in Hoxton Square. The beer they produced was nothing short of astonishing, and in 1987 their marvellous Dark Star was named Champion Beer of Britain at the Great British Beer Festival. In 2000 they were certified as the first 100 per cent organic brewery in the United Kingdom and are today still brewing, although are now based in Essex.

## Meantime

In 2000, South Londoner Alistair Hook founded the Meantime Brewery in Charlton. Hook had a degree in brewing from Edinburgh's Heriot-Watt University and had gone on to study further in Munich. He then worked at breweries in Italy, Kent and later the Freedom Brewing Company in Fulham. By 1996 he was working for the restaurateur Oliver Peyton, running the brewing operation at the Mash and Air chain of eateries.

Brewer Ciaran Giblin at the Meantime Brewery, Greenwich.

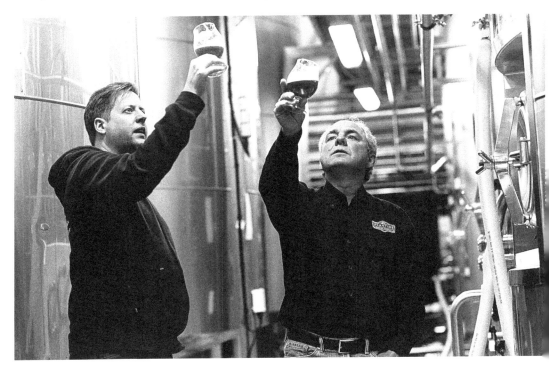

Meantime's Ciaran Giblin and, on the right, brewery founder Alastair Hook.

*Above and opposite*: Started in 2000, Meantime is now London's second oldest brewery.

But Hook was a man with his own vision, and in the spring of 2000 Meantime produced their first beer, Union Lager. Since then they have gone from strength to strength. Production has increased, as has the range of beer, which includes regulars such as London Pale Ale, London Lager and London Stout, alongside limited edition one-offs. I am still enveloped by a warm glow when I remember the barrel-aged Greenwich Hospital Porter that they brewed for Marks & Spencer a few years back.

In May 2015, Meantime were bought by the brewing giant SAB Miller for a sum estimated at around £120 million. In October 2016, they changed hands again when sold by SAB Miller to the Japanese brewer Asahi. Despite these changes in ownership, they are now London's second oldest brewery behind Fuller's.

The transformation, then, is truly remarkable. From having just nine brewers in 1976, the capital can now boast more than a hundred, and what's more is that they can be found at all points of the compass.

## New Breweries

In the year 2000, Zerodegrees started brewing in Blackheath, and was one of the first microbreweries to realise the possibilities of matching beer and food. Their 'state-of-the-art computer-controlled German plant' is located in the heart of their own restaurant. Considering they are fast approaching their twentieth anniversary, perhaps Zerodegrees don't get the credit they deserve for their part in London's brewing renaissance.

*Above, below and opposite above*: Duncan Sambrook (above) started his eponymous brewery back in 2008. Ralph and Craig head the brewing team.

*Above and overleaf*: Charlie and Sam, founders of the Gypsy Hill Brewery, with head brewer Simon on the right.

In 2008, Duncan Sambrook, tired of his City day job, started the eponymous Sambrook's Brewery in a former photographer's studio in Battersea, South West London. Also in South London, the Brixton Brewery have been in operation since 2013, and produce a range of beers that reflect their corner of London, namely the cosmopolitan and diverse nature of SW9. Empire Windrush Imperial Stout and Windrush Stout are a nod to the Windrush Generation, who arrived in London from Jamaica in the late 1940s, many making Brixton their home.

Not that far as the crow flies you'll find the Gipsy Hill Brewing Company in West Norwood, which has been brewing since 2014. They produce a number of well-balanced beers, and are also behind the fascinating IPA Heritage project, a three-month experiment that saw them attempt to recreate some of the conditions in which an old-style London IPA would have conditioned. In place of an East India Company frigate sailing half way around the world, Gipsy Hill instead enlisted the help of Thames boat operators City Cruises. A batch of IPA was brewed using traditional hops, such as Admiral and Pilgrim alongside UK Chinook, The final brew was then racked into wooden casks and stored on a working Thames vessel to try and emulate the rocking motion of the waves.

## Bermondsey Mile

The area of Bermondsey has historically had strong links with the brewing industry, so there is a real resonance that today the vicinity houses a concentration of new London brewers.

Fourpure, set up by brothers Dan and Tom Lowe, have been in action since 2013, while Brew By Numbers, founded by Dave Seymour and Tom Hutchings, have been

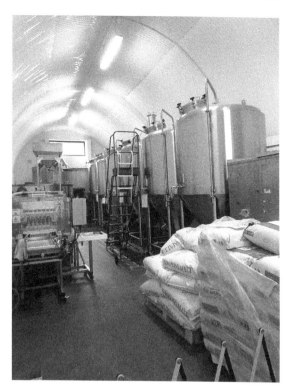

*Right and below*: Fermenters at the Partizan Brewery, which also opens its tap on Fridays and Saturdays.

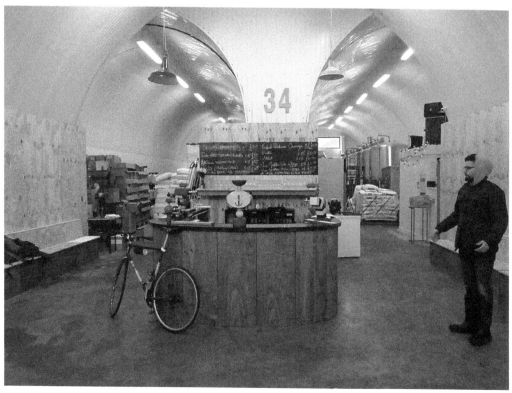

brewing in Southwark since 2011. Anspach & Hobday, founded by Paul Anspach and Jack Hobday, have been brewing in Bermondsey since 2014, and the Southwark Brewery started the same year.

The Partizan Brewery was set up by Andy Smith in 2012. With a background in the high-end restaurant industry, Smith already knew a thing or two about flavours and wanted to set about producing 'fresh' and 'exciting' beer. He cut his teeth at the Redemption Brewery in Tottenham, North London, and was soon brewing in his own right. With some distinctive bottle labelling, courtesy of artist Alec Doherty, Partizan produce beer that is both contemporary but also inspired by the past. My research for this book involved trying both their Stout and their Imperial Stout, both of which impressed this drinker greatly.

But no look at the current brewing scene in South London – indeed London as a whole – can be complete without mention of the Kernel Brewery, which has been leading the way since 2010, when it was set up by brewer Evin O'Riordain. The demand for, and reputation gained by, their beer forced it to relocate to bigger premises two years later, and from beneath rumbling railway arches in deepest Bermondsey they produce a wonderful array of beers.

Partizan Brewery beers have a distinctive look, courtesy of artist Alec Doherty.

*Above*: The Partizan is located beneath railway arches in Bermondsey.

*Right*: Beer aging in oak casks at the Kernel, Bermondsey.

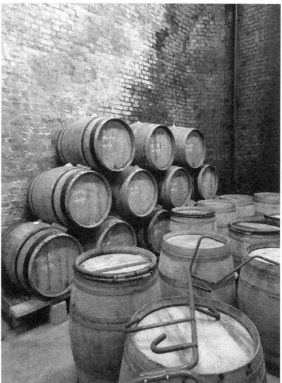

Fermentation vessels and the bottling line at the Kernel Brewery.

These include an easy-drinking and deliciously refreshing table beer, at least two contemporary pale ales and also some wonderful dark beers. Among the latter there is a truly spellbinding Imperial Brown Stout, which is based on an old recipe used by Barclay Perkins in 1859. It is a real taste of London's liquid history, and the fact that the Kernel are based within walking distance of the old Anchor Brewery only adds to the beer's historical integrity.

## Craft Giants Emerge

As the craft beer revolution took hold in London, there emerged a number of breweries that became giants of the movement.

Beavertown was started on a homebrew scale by Logan Plant back in 2011, equipment for early brews including an old tea urn and a camping cool box acting as copper and mash tun respectively. A bigger and more permanent home was soon found at Duke's Brew and Que restaurant in North London. It was here that two of the brewery's signature beers were created, namely Neck Oil and the awesome Gamma Ray.

But as demand increased production was moved, first to a 'lock-up' and later to an industrial unit in Hackney Wick. By this time Beavertown's beer was the talk of London. In 2014 a relocation to Tottenham saw them move into two side-by-side units, and they have continued to flourish ever since. Their Saturday taproom events have become legendary.

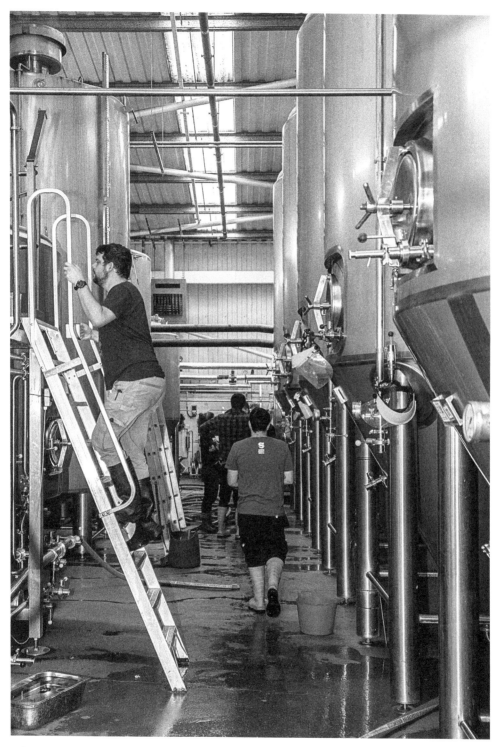

*Above and overleaf above*: From modest beginnings, Beavertown has become one of London's biggest craft brewers.

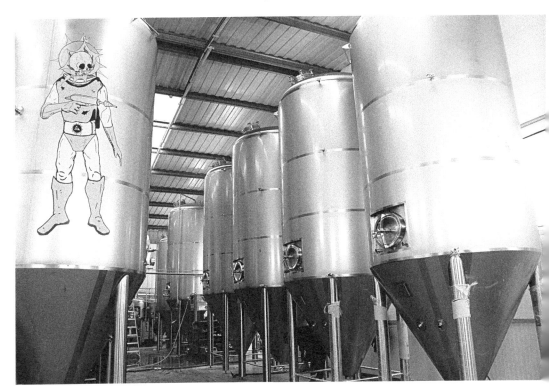

Beavertown's brewery tap is popular with discerning drinkers.

*Above and below*: Open day at the Camden Town Brewery.

Also started in 2011 was the Hackney Brewery, founded by Peter Hills and Jon Swain. Like Beavertown, their beers are full of character and command a cult following. They also remain independent, although not all of the big craft brewers have been able to resist the overtures of the established big brewers.

The London Fields Brewery, founded in 2011 by Julian De Vere Whiteway-Wilkinson and Ian Burges, was acquired by the brewing giant Carlsberg in July 2017. But perhaps the biggest shock for the craft beer community came two years earlier, when the Camden Town Brewery was bought by Anheuser-Busch InBev, brewers of global brands such as Budweiser and Stella Artois, for a sum believed to be in the region of £85 million.

Camden Town was started by Australian Jasper Cuppaidge in 2010, originally based beneath railway arches in Kentish Town, North London. Their Hells Lager quickly became one of the most popular craft beers on the market, and since 2015 has become a mainstream brand. In 2017, to help cater to the phenomenal demand for their beers, the brewery moved the bulk of production to a new £30 million facility in Enfield, which has a capacity of 88 million pints a year. In July 2017 Cuppaidge told *The Observer*, 'There is a total authenticity to us and our brand. For us, craft is a way of thinking.'

*Left and opposite*: Jasper Cuppaidge, the founder of Camden Town Brewery. Their beer can be found all across the capital.

## More Brewers

The East London Brewery, or ELB, was started in 2011 by husband and wife team Stu Lascelles and Claire Ashbridge-Thomlinson. Both gave up their day jobs to pursue their dream. It was a gamble that looks to have paid off as they now operate from a ten-barrel plant in Leyton and produce a range of beers that are popular in both cask and bottle.

Five Points are in Hackney Downs, while both Redchurch and Three Sods are based in Bethnal Green. Started in 2014, the One Mile End Brewery, as the name suggests, started life beneath the White Hart Pub, which is located at Number One Mile End Road, but the brewery has since relocated to Tottenham. N17 is a bit of brewing hub in its own right, and here you will also find Affinity, Brewheadz and Pressure Drop (who moved here from Hackney), not to mention Andy Moffat's highly regarded Redemption Brewery, which got the whole N17 ball rolling back in 2010 after Moffat had left a well-paid City job to brew full time.

Fuller's remain the dominant West London brewer – and indeed the dominant London brewer – but there are a few others in this neck of the woods that are producing some great beer, most notably The Portobello Brewery, which was started in 2012 using a ten-barrel plant located on an industrial estate near White City.

Their range of beers are imminently drinkable, in keg, cask, can and bottle, and also reflect the West London neighbourhood from which they come. There is, for instance, a Westway Pale Ale and a Market Porter (Portobello Road Market isn't far away, after all).

*Above left and right*: Hops go into the copper at the East London Brewery.

*Below*: The end product, boxed up for distribution.

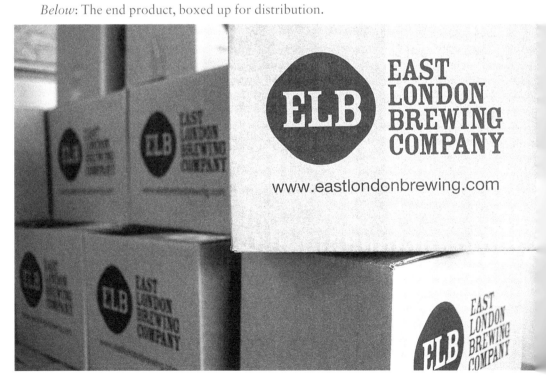

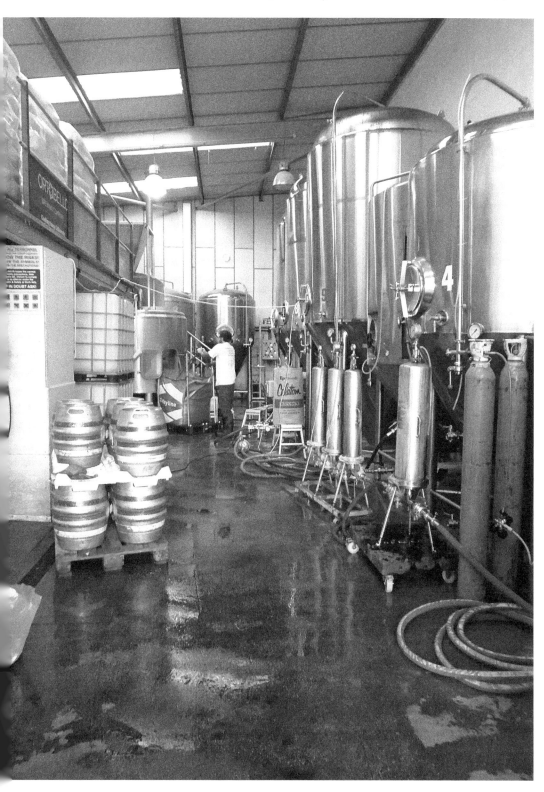

*Above, left and previous page*: Another busy day at the Portobello Brewery.

## Old Names Return

There are now more than 100 breweries operating in the Greater London area, and among the lengthy roster two names from the past have made a welcome return.

The Hammerton Brewery started way back in 1868, based in Stockwell, South West London, although brewing is believed to have been carried out on the same site since at least the early eighteenth century. Although always much smaller than the likes of Courage, Truman and Whitbread, they enjoyed a moderate degree of success and were awarded a Gold Medal for their Oatmeal Stout on more than one occasion in the late 1930s. A claim has been made that Hammerton's were the first brewer to use real oysters in the brewing process. In 1951 they were gobbled up by Watney and promptly disappeared.

*Right and overleaf*: The old Hammerton name has been revived and regenerated for the craft beer generation.

That could have been the end of the story, but in 2014 the name was revived when the Hammerton Brewery was founded by Lee Hammerton, a descendent of the original Hammerton brewing family. Based on an industrial estate in Islington, the new Hammerton's produce a diverse range of beers that reflect their relocation from South London to North. These include Pentonville Oyster Stout and Islington Steam Lager.

## Truman Reborn

For me personally, the most touching story to emerge from the renaissance of London's brewing industry is the return of Truman's, one of the most famous names in brewing history.

The original Truman stopped brewing in 1989, to the astonishment of many. In 2010 James Morgan and Michael George Hemus managed to acquire the right to use the old Truman name, at first under licence before eventually buying it outright. In 2013 they opened The Eyrie, a new forty-barrel brewery in Stour Road, Hackney Wick, which cost around £1 million to set up.

They haven't looked back since, brewing some amazing beers that both manage to reflect Truman's rich brewing heritage with contemporary values and flavours. These include Runner, a traditional session bitter, and Swift, a vibrant golden ale. Other beers include, all in keg, Pale Ale, IPA and a craft lager.

Intriguingly, they have also managed to track down an original Truman strain of yeast, dating from the 1950s and stored in liquid nitrogen at the National Collection of Yeast Cultures in Norwich. They are now using this old Truman yeast to make new Truman beers. There have also been beers based on recipes from the Truman's archive, including Keeper, a Double Export Stout of 1880 origin, and also a barley wine, dating from a 1916 recipe.

This all brings us full circle and confirms that London can once again claim to be among the world's great beer destinations. I'm sure you'll all join me in drinking to that.

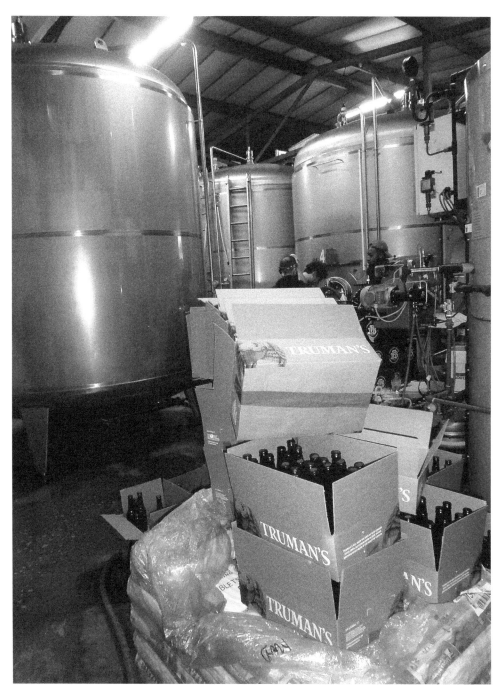

Inside the new Truman brewery at Hackney Wick.

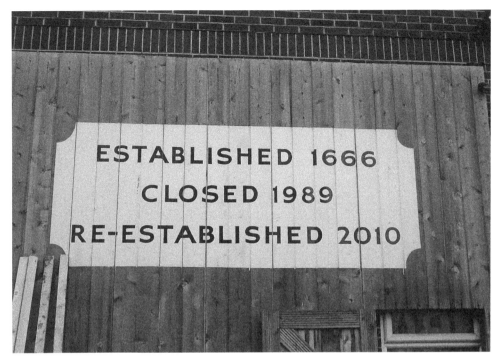

The new Truman's are clearly proud of the old Truman's rich heritage.

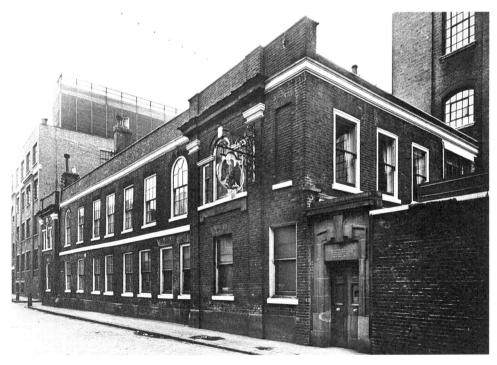

*Above and opposite*: The old Truman brewery, Brick Lane, and the new Eyrie in Hackney Wick on the right.

# Acknowledgements

I am grateful to a number of people who have helped in one way or another with the production of this book. I would like to thank all of the people at all of the breweries who gave up their valuable time to answer my enquiries and, in several instances, allow me to visit them. So thanks are due to Georgina Wald and her team at Fuller's who allowed me to use some of their archive material, and likewise Ben Watts Stanfield at the reborn Truman's. And once again, Peter Dickinson at the Labologists Society was a star. I'd also like to say 'cheers' to Andy Smith at Partizan Brewing, Lee Hammerton at Hammerton, Claire Ashbridge-Thompson at the East London Brewing Company, Sam Millard at Beavertown, Daniel Eilenberg at Portobello, Evin O'Riordan at the Kernel Brewery, Madeleine Blackall at Meantime, Michael Huddart at Gipsy Hill and Tom Kerevan at Sambrooks.

I would also like to thank my colleagues at Shepherd Neame for their encouragement and also my friend, and occasional 'research assistant', Martyn Hewitt for allowing me to borrow from his extensive library (there's a pint of Scruttock's Old Detergible in the wood for you).

Most of all I want to thank my wife Lydia and my daughter Harriet, who continue to put up with me spending long hours locked away in my 'den'.

# Bibliography

In addition to the books detailed below, there were two websites that I found invaluable. One is Martyn Cornell's authoritative and entertaining zythophile blog (zythophile.co.uk) and the other is the website of the Brewery History Society (www.breweryhistory.com).

Baillie, Frank, *The Beer Drinker's Companion* (Newton Abbot: David & Charles, 1973).
Bermant, Chaim, *London's East End – Point of Arrival* (New York: Macmillan Publishing, 1975).
Brown, Mick, *London Brewed* (Longfield: Brewery History Society, 2015).
Cornell, Martyn, *Amber, Gold and Black* (Stroud: The History Press, 2010).
Glover, Brian, *Camra Dictionary of Beer* (London: Longman Press, 1985).
Hackwood, Frederick W., *Inns, Ales and Drinking Customs of Old England* (London: Bracken Books, 1985).
Haydon, Peter, *Beer and Britannia* (Stroud: Sutton Publishing, 2001).
Jackson, Michael, *Great Beer Guide* (London: Dorling Kindersley, 2000).
Janes, Hurford, *The Red Barrel* (London: John Murray, 1963).
Langley, Andrew, *London Pride* (Melksham: Good Books, 1995).
Protz, Roger (ed.), *Camra's Good Beer Guide 2018* (St Albans: Camra Books, 2017).
Pudney, John, *A Draught of Contentment* (London: New English Library, 1971).
Sarto, Darcy, *Lady Don't Fall Backwards* (Otley: Skerratt Media, 2014).